1. Joseph Cornell, The Gift, *c. 1960s, collage, 14-3/4 x 12-5/8 in. (framed).
Photograph courtesy The Pace Gallery, New York.*

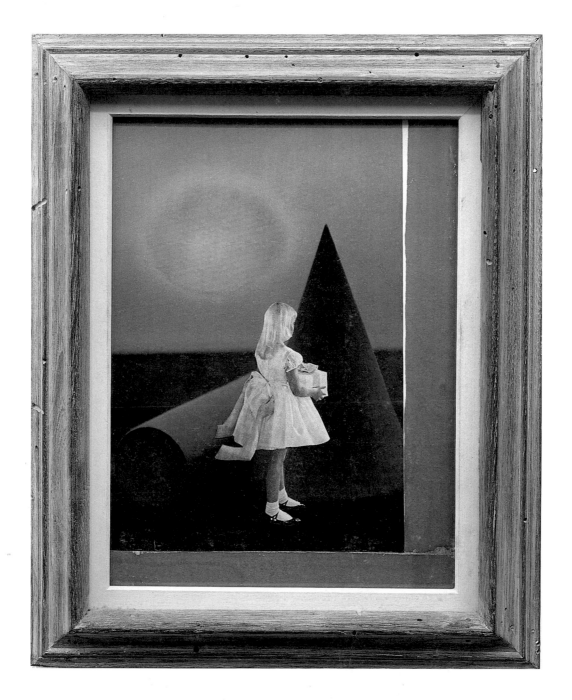

Joseph Cornell: Gifts of Desire

by Dickran Tashjian

GRASSFIELD PRESS, MIAMI BEACH

First published in the United States of America in 1992 by
GRASSFIELD PRESS, INC.
P.O. Box 19-799
Miami Beach, Florida 33119

Library of Congress Catalog Card Number: 92-71513

ISBN 0-9628514-2-6 (hardcover)
ISBN 0-9628514-3-4 (softcover)

Cover: *Joseph Cornell,* For Josephine, *1955, collage, 12-1/16 x 8-3/4 in. Collection Lois Smith, New York.*

Contents

Preface

\mathcal{D}ICKRAN TASHJIAN PROVIDES A FRESH ANALYSIS of Joseph Cornell (1903-1972) by focusing on works that were conceived as gifts to ballerinas, actresses, poets, and historic figures. Gifts had many meanings for Cornell, as Tashjian reveals. By creating collages and boxes as presents and personal homages, Cornell, who lived in Flushing, New York, connected his life with that of Marianne Moore, Hedy Lamarr, Lauren Bacall, and other glamorous and talented personalities. Most significantly, Cornell's gifts often required the participation of the recipient in an exchange that heightened the pleasure of creating. His collaborations and interactions with women artists associated with Surrealism, as explored here, were an extension of this characteristic of gift-giving.

Cornell's imagination roamed through time and space, and, as Tashjian observes, he was constantly bringing historic figures into the present. The ballerinas of the Romantic Age seemed as alive in Cornell's mind as their contemporary counterparts with whom he actually associated. He also searched the past for counterparts to himself, sympathizing, for example, with the reclusive Emily Dickinson and identifying with King Ludwig II of Bavaria, whose patronage of the arts became a model for Cornell's interest in the ballet. Tashjian's extensive research of Cornell's diaries and even the marginalia noted in key books in the artist's library sheds light on Cornell's relationships and identification with such individuals who provided inspiration for his works. His homage to Ludwig II is discussed here in depth for the first time, as is his salute to Lauren Bacall. In his tributes to Bacall and other movie stars, Cornell emerges as a cultural commentator of the first order who freely blended fine and popular art as well as European and American traditions.

Although Cornell's collages and boxes seemed anomalous in the 1950s and 1960s when abstract painting dominated the art scene in the United States, his influence today is widespread and evident in the work of assemblage artists. Moreover, his work anticipated a number of issues prevalent in contemporary cultural discourse, in particular, debates on the relationship between "high" art and popular culture, women and Surrealism, and the significance of gift-giving. We are very pleased, therefore, to publish this timely study, and would like to extend our appreciation to Dickran Tashjian for writing this compelling evaluation of Cornell's work. It was truly a delight working with him on this publication.

We would like to join the author in thanking the following for their generous assistance. We are deeply appreciative of the cooperation of Richard M. Ader and Donald Windham, Trustees, The Joseph and Robert Cornell Memorial Foundation, for permission to reproduce works by Cornell, and Edward Batcheller for permission to quote from Cornell's writings.

We wish to thank Douglas Baxter of The Pace Gallery, New York, for his early encouragement of the project. The assistance of Janice Vrana, the gallery's archivist, was indispensable and we would like to extend to her our gratitude. Scholars, curators, archivists, and individuals were generous with their resources and we would like to thank, in particular, Mary Ann Caws, Whitney Chadwick, Andrea Clark, Registrar, Norton Simon Museum, Pasadena, California; Lynda Roscoe Hartigan, the Joseph Cornell Study Center, National Museum of American Art, Washington, D.C.; George Hunt, Charles Krinsky, Duane Michals, Richard Press, Eloise Ryan, Sandra Leonard Starr, and Ann Tashjian.

Many individuals, institutions, and galleries provided photographs and permission to quote from archival sources. Their cooperation and diligence were essential to this project. We thank Eve Babitz; Lindy Bergman; Robert Bergman; John Cavaliero, Cavaliero Fine Arts, New York; Diana Edkins, Permissions Editor, The Condé Nast Publications, New York; Charles Henri Ford; Robert Haller, Anthology Archives, New York; Vivian Horan; John Kaiser, Editorial Associate, The Menil Collection, Houston; Lincoln

Kirstein; Katrina Leslie, Penrose Film Productions, East Sussex, England; Robert Lehrman; Bethany Mendenhall, Head, Technical Services, The Getty Center for the History of Art and the Humanities, Santa Monica; Lieschen Potuznik, Coordinator of Photographic Rights, The Art Institute of Chicago; Natania Rosenfeld, Assistant Curator of Books and Manuscripts, The Rosenbach Museum and Library, Philadelphia; Lois Smith; Charles Stuckey, Curator of Twentieth-Century Art, The Art Institute of Chicago; Dorothea Tanning; Judy Throm, Archives of American Art, Smithsonian Institution, Washington, D.C.; Samuel Lorin Trower, Richard L. Feigen & Co., New York; Barbara Wilson, Archives of American Art, Los Angeles Regional Office; and Rachel Blackburn Wright, Registrar, Modern Art Museum of Fort Worth.

At the University of California, Irvine, we would like to thank June Kurata and Elizabeth Schiller of the department of comparative culture, and Sylvester Klinicke and Eddie Yeghiayan of Special Collections. Our gratitude goes to Naomi Sawelson-Gorse for her assessment of archival and research materials. Her assistance and recommendations were most welcomed.

The attention Terry Ann R. Neff gave to the copy editing of the manuscript is greatly appreciated. Our thanks to Janet Eaglstein for proofing the text. It was a great pleasure working with John Campbell on the design of this publication. We are especially grateful to Buzz Spector and Cesar Trasobares who made creative use of this book in their homages to Cornell.

For their very generous assistance we thank Estelle and Paul Berg. Our gratitude also goes to Nick and Shauna Brown, Bernard and Adele Cohen, Jane and Jim Cohen, Barbara and Avram Jacobson, Juan Lezcano, Robert Littman, Elise and Stephen Markarian, Kathy and Jim Muehlemann, Melanie Wong, and Michéle Wong for their belief in this project.

Our special thanks go to Craig Robins for his generosity of spirit.

Bonnie and James Clearwater
Publishers
Grassfield Press

Joseph Cornell: Gifts of Desire

Prologue

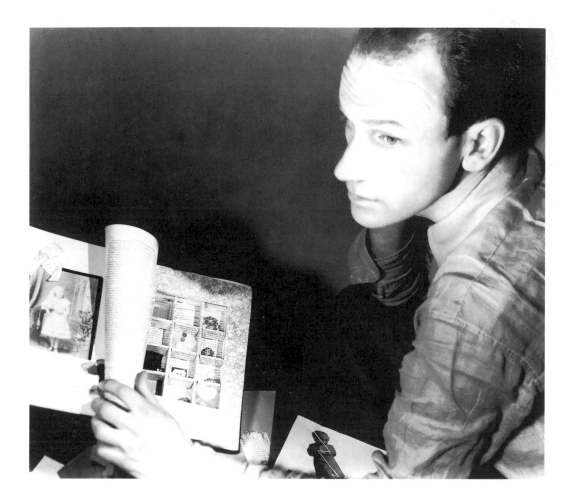

2. Joseph Cornell, c. 1940. Photograph courtesy Joseph Cornell Study Center,
National Museum of American Art, Smithsonian Institution, Washington, D.C.

\mathcal{J}OSEPH CORNELL WAS BORN IN NYACK, NEW YORK, in 1903, the eldest child of prosperous parents. The happy family life he shared with his two sisters and a brother may account for the childlike wonders of his work. The death of his father when Joseph was fourteen disrupted Cornell's life. Forced to supplement depleted family income in 1921 after attending Phillips Academy in Andover, Massachusetts, he found the life of a Manhattan textile salesman difficult at best. He ultimately retreated to free-lance commercial art projects as a means of support for his mother and invalid brother, Robert. Cornell, who remained unmarried, lived with them in a modest house at 3708 Utopia Parkway in Flushing, New York.

Cornell was anomalous in many ways: middle-class in his daily life yet intensely interested in New York's avant-garde; without college education and self-taught as an artist yet formidably knowledgeable about film, dance, music, and literature. His own work has remained difficult to categorize. Dubbed "the Benvenuto Cellini of Flotsam and Jetsam" by his friend, writer Parker Tyler, Cornell frequented the used bookstores, thrift shops, and flea markets of lower Manhattan in search of castoff material to incorporate into his "objects," as he called them.[1] He himself was bemused to think that his boxes might be viewed as sculpture; in the main they have been identified as assemblage, that protean catch-all of the twentieth century.

Partly because his entry into the art world during the 1930s coincided with the appearance of Surrealism in Manhattan galleries, Cornell's work was generally characterized as Surrealist in quality. Even so, in perfecting his boxes as a variation on the Victorian shadowbox, he appropriated a format that the Surrealists used infrequently, despite their collective interest in

1. Parker Tyler's inscription, dated January 18, 1941, is on the inside cover of his volume of poetry, *The Metaphor in the Jungle, and other poems* (Prairie City, Illinois: Press of James A. Decker, 1940), in box 98 of Cornell's library, Joseph Cornell Papers, Archives of American Art, Smithsonian Institution, Washington, D.C. For biographical details of Cornell's life, see Lynda Roscoe Hartigan, "Joseph Cornell: A Biography," in *Joseph Cornell,* ed. Kynaston McShine (New York: The Museum of Modern Art, 1980), pp. 91-119.

assemblage. In gradually developing the box from his early response to Max Ernst's collages, Cornell had virtually no precedent among modern artists, let alone the Surrealists. After his retrospective exhibition in 1980 at The Museum of Modern Art, New York, the Surrealist label was reevaluated in view of Cornell's devout adherence to Christian Science.[2] Despite their usefulness, neither Surrealism nor Christian Science fully addresses the nuances and complexities of his work. As a consequence, many questions still persist about the meaning of his boxes and collages.

Our understanding has been all the more limited by the way in which a fictitious Cornell has emerged over the years. The critic Hilton Kramer's characterization of Cornell, written on the occasion of his retrospective, offers a glimpse of such a figure. With Cornell's "odd and eccentric talent," we become privy to a "vision of an ideal innocence," and so we enter an "enchanted universe where even the commonplace becomes exquisite, and Eros demands nothing but esthetic gratification."[3] Such an appraisal obscures the subtle power of Cornell's work.

It has become all too inviting to see Cornell as embodying a tamed Eros because he made objects that seemingly traffic in nostalgia, ethereal nuance, and innocence above all. This biographical fallacy in turn reinforces the perception of his works as the charming creations of an innocent, eccentric artist. It is beyond the scope of this project to present a detailed account of Cornell's life. At this juncture, his work calls for new inquiry. To clear the way, Cornell's objects need to be restored to their complexity, which has been obscured by the frequent conjuring of "mystery," "enchantment," and "innocence"—buzzwords that often excuse us from closely examining his work.

For a different approach, I have taken my cue from the dance critic

2. For the most extensive analysis of Cornell through the lens of Christian Science, see Sandra Leonard Starr, *Joseph Cornell: Art and Metaphysics* (New York: Castelli, Feigen, Corcoran, 1982), pp. 1-8. Also see Hartigan, "Joseph Cornell: A Biography," pp. 91-119.
3. Hilton Kramer, "Art: Joseph Cornell's Shadow-Box Creations," *The New York Times*, November 18, 1980, sec. C, p. 10.

Donald Windham, whose friendship with Cornell dated to their editorial efforts for *Dance Index* during the 1940s. In an elegiac article on Cornell in 1980, Windham spoke of the artist's inability at the outset of his career—and well beyond—to sell his objects. As a result, he decided to keep them for himself and his family or to give them to appropriate friends and even casual acquaintances. Dancer Allegra Kent recalled "a little book *Secrets of Flowers* that he gave me as a remembrance" of a wonderful summer visit in 1969. The art historian Sam Hunter acknowledged a "charming and mysterious small package" for his five-year-old daughter, who received a "royal blue little box with its cheerful yellow wrapping, and treasure enclosed." Perhaps his greatest gift to children was the "For Children Only" exhibition of his work in 1972 at New York's Cooper Union School of Art and Architecture, where he graciously discussed the objects with his young audiences.[4]

We shall never know how many objects were intended as gifts until a catalogue raisonné has been prepared, and perhaps not even then, because Cornell's giving made up a kaleidoscopic pattern, with countless permutations and combinations of gifts and recipients. In the meantime, we know that some objects and collages were gifts because Cornell indicated as much in his letters and diaries, or the works were so inscribed. He personalized many of those objects by making references that pertained directly to the recipient. In this way he had the pleasure of making something with a person in mind; thinking about the recipient also kept his project alive.

Those objects that Cornell intended as gifts varied in scope and intensity. Some gifts were objects for specific individuals, while others were simply small tokens of affection, meant to delight and amuse, which Cornell frequently

4. Donald Windham, "Joseph Cornell's Unique Statement," *The New York Times*, November 16, 1980, sec. D, pp. 27-28; Allegra Kent, "Joseph Cornell: A Reminiscence," in *Joseph Cornell Portfolio-Catalogue*, ed. Sandra Leonard Starr (New York: Castelli, Feigen, Corcoran, 1986), np; Sam Hunter to Cornell, August 26, 1960, Cornell Papers, roll 1055, fr. 265. For the Cooper Union exhibition, see "Cornell's Homage to Children," in Dore Ashton, *A Joseph Cornell Album* (New York: The Viking Press, 1974), pp. 221-32.

enclosed in his correspondence or affixed to his letters as *papiers collés*. On occasion, he collaborated in an exchange with other artists that resulted in a shared work of art, a mutual gift, as it were. His most elaborate gifts were constructions Cornell offered as homage to individuals whom he admired from afar—across time or distance. These celebrations variously assumed the format of box, valise, or dossier, sometimes in complex combination.

I have selected examples from this cross-section of objects that Cornell conceived as gifts. An awareness that some works were gifts enhances their meaning, and in some instances even discloses their meaning for the first time. Cornell himself was very sensitive to the implications of giving gifts. First and foremost, he viewed gifts as a way of connecting with other people. This social transaction was fraught with significance for the meaning of his work. Beyond rational exchange, Cornell sensed that a gift had the power to join donor and recipient together in mutual desire. By making gifts of his work, he was presenting a part of himself, as *his* time, effort, and care were integral to the assemblage passed into the hands of his recipients. His pleasures in the making were reiterated by a recipient's tactile manipulation of a box's contents.[5]

At their most intense, Cornell's desires engendered complete identification with the other. Allegra Kent reminisced that he wanted to be her double. But then he identified with many women whom he loved and admired, most often from afar. Gift giving with such motivation created anxieties beyond those inherent in ordinary exchange. Each presentation risked a misunderstanding that was tantamount to rejection. To compound the problem, Cornell often invested his gifts with visual motifs of gender doubling, sexual

5. In thinking about gifts, I am greatly indebted to the insights of Lewis Hyde, *The Gift: Imagination and the Erotic Life of Property* (New York: Vintage Books, 1983), p. xiv n, where he broadly defines eros as "the principle of attraction, union, involvement which binds together," from which logically follows his characterization of "gift exchange as an 'erotic' commerce." Hyde's expansive definition of eros especially fits Cornell, who modulated the desires of gift exchange from chaste to sexual feelings, both disguised and overt.

metamorphosis, and androgyny. Such images transgressed cultural norms even though his offerings were made out of reconciliation and love. By rendering these images in a subtle fashion, he left the significance of his gifts open for interpretation by the recipient. [6]

Cornell found a guide to help him negotiate this ambiguously erotic terrain. As a practicing Christian Scientist whose faith assuaged intermittent but profound moments of anxiety and alienation, Cornell turned daily to the lessons of Mary Baker Eddy in her book *Science and Health*. Though she was prey to gender stereotypes in defining the male according to creativity and intelligence, the female procreativity and love, Eddy claimed that marriage provided an opportunity to blend those qualities, leading to a spiritual unity. Like Mother Ann Lee, who founded the Shakers earlier, Eddy projected a dual God that is both Father and Mother.[7] For Cornell, then, a sexual identity that embraced male and female symbolized love and creation on a high spiritual plane. He intended his objects to achieve a spiritual unity that Eddy extolled, especially when he offered them as gifts to women.

Cornell's objects, however, are more than a gloss on Christian Science theology. He sought other compensations by exercising the life of his imagination and ceaselessly seeking connections. Collage and assemblage became his way to mend disconnections and provide the satisfaction of bringing images together. He found those satisfactions, like his spiritual aspirations, difficult to attain. A knowledge of what Cornell confronted in his experience will reveal the authenticity of his achievement. He was hardly the quintessentially "innocent" artist, indifferent to erotic possibilities in his

6. Kent, "Joseph Cornell: A Reminiscence." The sexual implications of Cornell's work, including doubling of gender and androgyny, have rarely been taken into account in the scholarship about Cornell, except for Marjorie Keller, *The Untutored Eye: Childhood in the Films of Cocteau, Cornell, and Brakhage* (Rutherford, Madison, and Teaneck, New Jersey: Fairleigh Dickinson University Press, 1986), pp. 105, 111-14.
7. Mary Baker Eddy, *Science and Health with Key to the Scriptures* (Boston: The First Church of Christ, Scientist, 1934), pp. 517, 57, 332. In her most radical statement, Eddy claimed that God in its embodiment of love might well be feminine (p. 517).

3. Joseph Cornell, Untitled (Blue Nude), *c. mid-1960s, collage, 11-1/4 x 8-1/4 in.*
Collection Robert Lehrman, Washington, D.C.

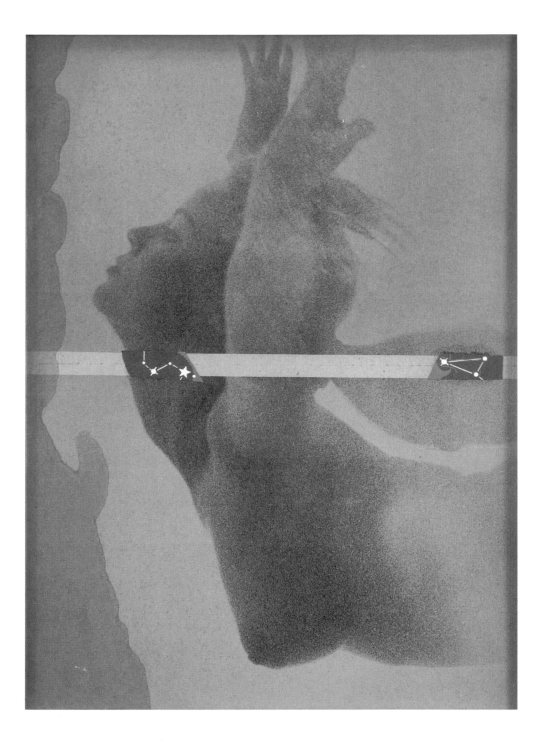

pursuit of spiritual purity.

At their most powerful and complex, Cornell's objects gain a spirituality *through* the materials that he brought together in full knowledge of their sexual implications.[8] As he grew older, his representations of women became openly erotic (pl. 3). He expressed his erotic interests to writer Eve Babitz, who, enthralled by his work, had telephoned him in 1966. In a letter of October 1, 1969, he asked Babitz (the nude in the famous 1963 photograph of a chess match with Marcel Duchamp) for some "'sylph' images," for he thought that "the [sex] mags [had] hit bottom for banality—& sordidness." He cited with approval a review in *The Christian Science Monitor* of his recent exhibition at the Rose Art Museum at Brandeis University in which some collages containing images of nude women were taken to be "symbols of simplicity, innocence & purity."[9]

To recover Cornell's gifts, an extensive reading of his diaries, letters, and notes, including the marginalia in the books that made up his library, is essential. Because of his strong literary interests and because he considered his work in constant progress, his writings are often an integral aspect of his constructions. Similarly, Cornell's passionate responses to his reading do not serve simply to catalogue his sources but provide clues to how he connected himself and his work to others in the past.

8. A useful phrase for the understanding of Cornell's metaphysical and spiritual impulses is "the generative finite," which involves an artist's imaginative "passage through the finite" of experience toward spiritual "insight" (William F. Lynch, *Christ and Apollo: The Dimensions of the Literary Imagination* [New York: Sheed and Ward, 1960], pp. 12, 18).

9. Cornell to Eve Babitz, October 1, 1969, Collection of Eve Babitz, Los Angeles; Christopher Andreae, "Cornell: boxes full of memories," *The Christian Science Monitor* (Eastern Edition), June 12, 1968, p. 14. The exhibition at the Rose Art Museum, Brandeis University, Waltham, Massachusetts, was held from May 20 to June 23, 1968. Walter Hopps, who was in the process of organizing an exhibition of Cornell at the Pasadena Art Museum (January 9-February 11, 1967), encouraged Babitz to see Cornell's work in New York. When she offered Cornell the famous photograph of her playing chess in the nude with Marcel Duchamp at the artist's retrospective in 1963, Cornell declined, preferring a "pin-up" (Babitz, telephone conversation with the author, March 11, 1992).

The web Cornell spun was complex and bewildering, often even to himself. As he confided to the poet Marianne Moore, "There seems to be such a complexity, a sort of endless 'cross-indexing' of detail (intoxicatingly rich) in connection with what and how I feel that I never seem to come to the point of doing anything about it."[10] It was not just the complexity of his experiences that led to Cornell's inertia, but also the sheer attraction of immersing himself in those experiences with their endless possibilities. At the same time, the risk of losing his feelings compelled him to secure them in his objects as best he could, and sometimes, he lamented, without success. And so he found himself conflicted between experience and art. While his original feelings may elude us forever, their traces are embedded in his allusions. Their dialogues with his work comprised his world and, recovered, will extend his gifts to us.

10. Cornell to Marianne Moore, June 21, 1944, V:12:11, Marianne Moore Archives, The Rosenbach Museum and Library, Philadelphia.

The Act of Giving: "The Spirit in which the Gift is Rich"

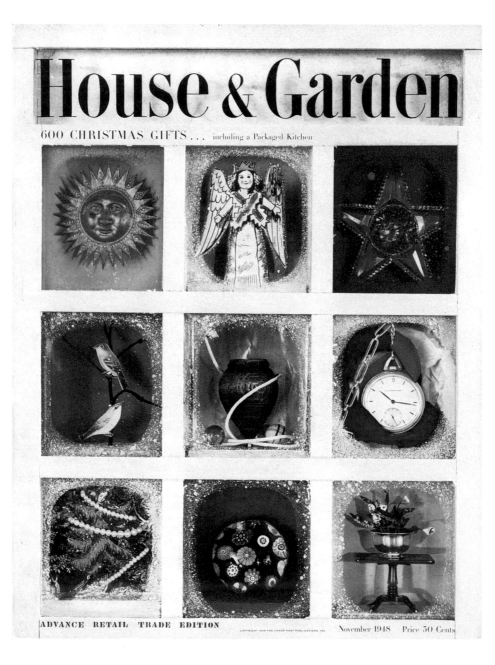

4. *Joseph Cornell, cover design for* House & Garden, *November, 1948.*
Photograph courtesy House & Garden.

\mathcal{J}OSEPH CORNELL'S GIFTS came doubly wrapped in desire and obligation. In being artistically gifted, he felt compelled to give, most frequently by offering his assemblages as presents. His objects, however, have been so absorbed by the art world that we have lost sight of their original guise as gifts. Instead, we press our noses against the museum vitrine and wistfully take in his boxes like forlorn children at Christmas, staring at presents sealed behind cold department-store windows, knowing that we shall never possess them. Born on Christmas Eve, Cornell tried to time his exhibitions for the holiday season in the hope that his offerings might be taken for the gifts that they were.

Cornell delighted in the spirit of Christmas and was even inclined to capitalize on the seasonal exchange of gifts. For the November 1948 issue of *House & Garden,* he designed a cover that displayed Christmas-gift suggestions through snow-flecked windowpanes (pl. 4). His sensibility was evident in the selection of an angel, a tree decoration, a sunburst, birds, a paperweight, and even a miniature silver bowl—icons that could melt any Scrooge. The grid pattern, formally striving for Mondrian's geometry, came from Cornell's own boxes, an untitled construction (pl. 5), for example, with niches containing colorful balls, blocks, shells, marbles, and ornaments. He retracted this construction's playful offerings, however, in *Nouveaux contes de fées,* which displays tiny boxes meticulously wrapped and shelved (pl. 6). With this object, ominously subtitled *Poison Box,* Cornell warned that fairy tales are dangerous, that the deep sleep induced by a poisoned apple proffers the risk of death as well as rebirth. Who knows which gifts are truly the most desirable?

Although Cornell knew how to pitch his smaller objects as seasonal gifts, he also managed to keep his gifts apart from the demands of market transactions. Whereas the contractual logic of the marketplace precisely outlines mutual obligations, gift-giving can generate a plenitude of responses and exchanges, as revealed by Cornell's diary entry for February 26, 1945. A rainy morning found him working at home on a "round box (minutiae)" titled *Mémoires de Madame la Marquise de Rochejacquelein.* He described with pleasure his concentration upon the intricate fragments that comprised this "minutiae": "blue sand under glass—cut up sentences; rearranged [and]

5. *Joseph Cornell,* Untitled, *c. mid-1950s, mixed-media construction, 18 x 11-1/2 x 2-3/4 in. Photograph courtesy The Pace Gallery, New York.*

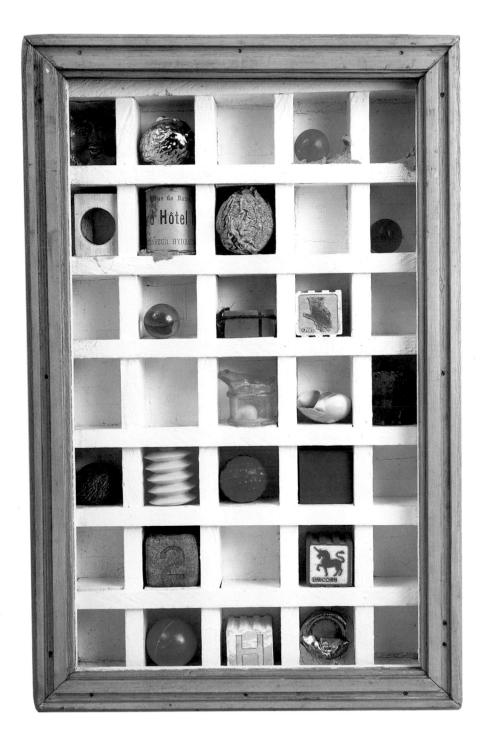

mounted on strips of glass—snips of old clothing to coincide with portrait inside cover of box." He made this small box as a gift for Alexander Liberman "in appreciation of [a] $425 check from Condé Nast—largest amount I've received at one time since leaving Wm. Whitman [in] 1931."[11] Because Cornell had been paid for services rendered, no gift was necessary. Gratified, however, by the size of the check, and the opportunity to earn his living, he personalized a contractual relationship with Liberman by making a gift for him.

Cornell went to great lengths to be generous as shown by his regret in promising one of his sisters that they should not exchange gifts one Christmas. He spent many nights wondering how to get around this promise, until he came upon an argument that would stymie her: "'Tis the spirit in which the gift is rich, as the gifts of the wise men were—and we were not told whose gift was gold or whose was the gift of myrrh[e]." Cornell's emphasis upon the spiritual value of a gift above its source and substance made his sister realize that he had gained license to give her a gift and "still keep" his "promise." All she could do was call him a "weasel" in mock exasperation.[12]

Apart from revealing an obligation that bordered on compulsion, the story is significant for what it tells us about Cornell's sense of gifts. The allusion to the Magi suggests that gifts can be sacred, at the very least, special. By extension, the giving of gifts can be a sacred act. Cornell's sister sought to interdict the powerful obligation (and desire) of giving and receiving presents at Christmas by appealing to her brother's honor. Thus in making the promise (clearly in a weak moment), Cornell found himself caught between two equally important obligations. Only an emphasis upon the spiritual value of a gift could free him from this double-bind.

11. Diary entry, February 26, 1945, Cornell Papers, roll 1058, fr. 921. For a discussion of the erotic commerce of the artist as opposed to the contractual demands of capitalism, see Hyde, pp. 143-59.
12. Undated diary fragments, Cornell Papers, roll 1058, frs. 64-65. Cornell did not indicate which sister was involved in this episode.

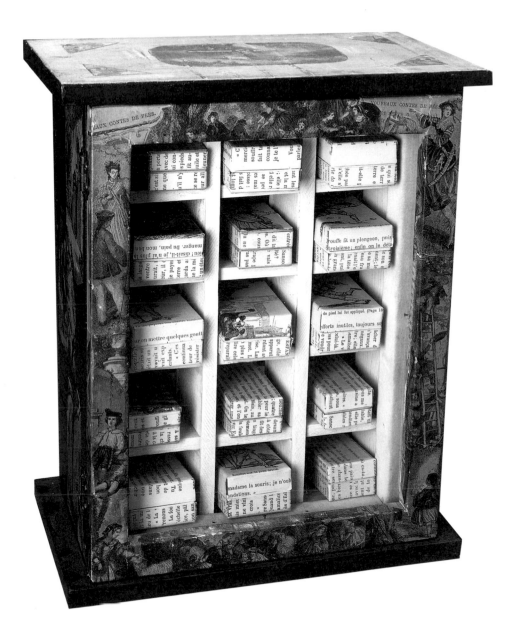

6. *Joseph Cornell*, Nouveaux contes de fées (Poison Box), *1948, mixed-media construction,*
12-5/8 x 10-1/4 x 5-7/8 in. Lindy and Edwin Bergman Joseph Cornell Collection,
The Art Institute of Chicago. Photograph courtesy The Art Institute of Chicago.

Even then, some sophistry prevailed, for a gift is rarely anonymous; it almost always bears the imprint of its donor, especially when the gift happens to be a work of art. Moreover, Cornell's assemblages during the 1930s, before he settled upon the now familiar box format, often took the guise of objects conventionally given as gifts. Alluding to toys, games, valentines, and shadow-boxes, these objects invited an intimacy on the part of a recipient. To be able to open a small hinged construction such as his *Homage to the Romantic Ballet,* to play with its crystals and peer into its sealed and concealed interiors from different angles, creates an opportunity to meditate upon the imagery at hand and to daydream about its meaning (pl. 34). Of even more explicit design for the curious, Cornell's valises and portfolios extend an open invitation to browse, ultimately to join the artist himself in the pleasures of (re)assembling his material in homage to those he admired.

Yet Cornell often kept his distance by mailing gifts. For example, Donald Windham received a letter in November 1972 just before Cornell died: "He wrote on the outside: 'No need to open.' The envelope was translucent. I could see that there was a small cutout or collage inside, but only one written word, 'tinsel!' And I have never opened it."[13] This account is especially telling. His letter diffidently asked Windham to go against custom even while the translucent envelope revealed its contents. Such reticence and indirection were typical of Cornell, both giving and withholding at the same time, thereby making the eventual contact with the recipient all the more important.

Years before, Cornell had sent a collage to the actress Lois Smith through Windham as an intermediary (pl. 7). He directed Windham to hang the collage (which incorporated a picture of the actress) in his apartment. If the actress took notice of it upon a visit and liked it, the collage should then be revealed as hers.[14] In this fashion Cornell posed a hidden test: by admiring

13. Donald Windham, "Things That Cannot Be Said: A Reminiscence," in *Joseph Cornell: Collages, 1931-1972* (New York and Los Angeles: Castelli, Feigen, Corcoran, 1978), p. 13.
14. Lois Smith, interview with the author, October 30, 1991. The story is corroborated in Windham, "Joseph Cornell's Unique Statement," p. 27.

the collage Smith would be worthy of receiving it. He interpreted her appreciation as an indication of spiritual rapport between the two artists. Only then did this gift lead to their meeting. Smith subsequently invited him to dinner and in turn he had her to lunch at Utopia Parkway, where he showed her his boxes in an upstairs parlor.

At the heart of this happy interaction was the gift itself and the circumstances of its making. In October 1955 Cornell had seen Smith on Broadway playing the lead in *The Young and Beautiful,* Sally Benson's adaptation of the Josephine short stories by F. Scott Fitzgerald. The actress later learned from Windham that Cornell had sat in the back of the Longacre Theatre and watched through his fingers, as though shutting out every distraction in order to concentrate on her performance. Cornell's attraction was confirmed when he and his brother, Robert, watched her in a live television drama on "Robert Montgomery Presents." She played Jenny Lind, the love interest of Hans Christian Anderson, in "The Second Day of Christmas"—favorite personages at a favorite time of year. He was apparently taken by her eyes, for several years later in his diary he wrote that he saw a woman with "*eyes*—evoking the 'something' from Lois," and he dubbed her "Lois Smith's 'sister.'"[15]

Cornell used the playbill for *The Young and Beautiful* in his collage. He cut out the image of Smith as Josephine, a bold young woman defying the social conventions of Chicago on the eve of America's entry into the First World War. Alternately cynical and vulnerable in the play, she remains honest with regard to her own emotions. Despite her physical attraction to a young flier on leave from the Allied forces, she confesses that she does not feel any love for him. Though Josephine might superficially be seen as a forerunner of the Jazz Age flapper, Cornell understood that she was poised between innocence and experience.

His collage offers a reprise to the poignant moment near the play's

15. Smith, interview with the author; diary entry, October 26, 1962, Cornell Papers, roll 1061, fr. 578. For the script of the play that Cornell saw, see Sally Benson, *The Young and Beautiful* (New York: Samuel French, 1956).

7. *Joseph Cornell*, For Josephine, *1955, collage, 12-1/16 x 8-3/4 in.*
Collection Lois Smith, New York.

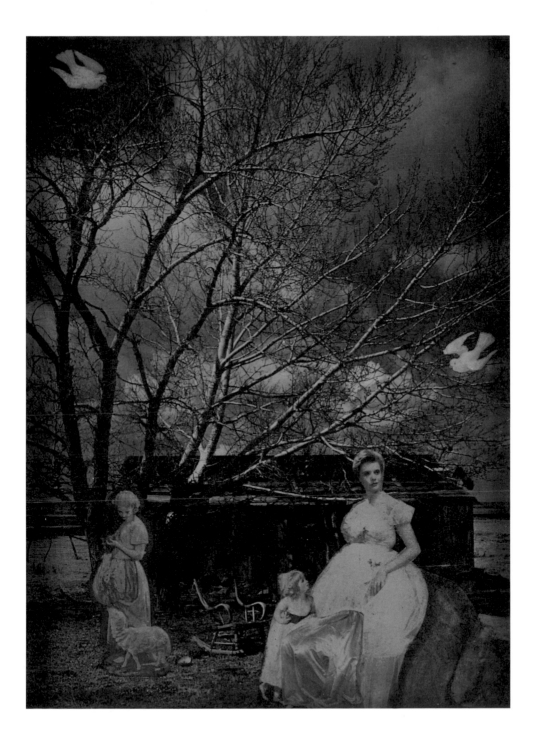

conclusion when Josephine is on the brink of emotional bankruptcy. With a little girl pressed up against her knees, Josephine is highlighted in a white gown, suggesting purity. Behind them is a rustic house set on flat land. A shepherdess with a lamb stands in front of a magnificent tree, its bare branches arching above the house. Two doves, symbolizing salvation, descend from the sky. The spiritual implications are clear, though the outcome is not.

Carefully collaged though they are, the figures of Josephine and her surrogates are nonetheless abstracted in the landscape. Cornell placed her distinct against a bucolic background, as though looking toward an uncertain future, while he outlined the shepherdess in blue, caught up in her own world. Seen through a deep blue glass, the tableau assumes the quality of a dream, heightened by the inscription on the back from the German Romantic poet Friedrich Hölderlin: "Home, poor heart, you cannot rediscover / If the dream alone does not suffice."[16] Be true to your dream, the poet speaks through Cornell, be true to yourself, Josephine, and you shall rediscover your home.

By inscribing the collage "for Josephine" on the back, Cornell left no doubt that the work was a gift. Perhaps he was hedging his bet. In the unlikely event that the young actress would ignore the collage incorporating her picture, then it would remain as a gift to "Josephine," a fictive female, a double brought to life in his imagination. By admiring the collage, Smith accepted it for herself and her alter ego, Josephine. The collage became a remembrance of a wonderful performance and Cornell's response to it. His assemblage was an attempt to rescue Josephine from emotional loss even as he counseled the young actress to be true to the dream of her craft, her home on the stage. What began with indirection finally went to the heart of the matter in Cornell's assemblage. An act of giving brought two artists together in an intimate moment, dramatized in an image that only they could fully comprehend.

Although Cornell conceived many of his works as gifts or homages, the

16. Cornell borrowed these lines from a poem titled "To Nature," published in *Some Poems of Friedrich Hölderlin,* trans. Frederic Prokosch (Norfolk, Connecticut: New Directions, 1943), np.

actual presentation of such objects was not always necessary (or even possible in the case of historical figures). Often, the intended recipients inspired "luminous" moments that Cornell had experienced and attempted to sustain. Two closely related collages of the early 1960s reveal the complex contradictions of his quest; both involve the idea of a gift. *How to Make a Rainbow (for Jeanne Eagels)* is an homage to the stage and silent-screen actress best known for her role as Sadie Thompson in the New York production of *Rain,* and who died in 1929 (pl. 8). In offering general commentary on the idea of gift exchange, *The Gift* (pl. 1) gains its power from the ambiguities generated in the wake of *How to Make a Rainbow.*

How to Make a Rainbow was inspired by a multitude of sources, including a rainbow which Cornell saw on August 20, 1963. He inscribed in his diary on that date, "How to Make a Rainbow," and added "on a rainy day." A few days later, he noted that viewing Kim Novak in "Jeanne Eagels" on television had triggered the collage. He was astonished by the biographical parallels he felt between himself and Eagels, "so rich & complex," that he regretted the loss of such "nuances." In his enthusiasm, Cornell extensively researched Eagels' life. What emerges from the urgently scribbled notations in his diary is a sense that the actress embodied for Cornell a complex bundle of exalted feelings: "Jeanne Eagels coming to life with this renewed force."[17]

Cornell's intense fascination with Eagels was not dispelled by this single work, and over the years he continued to collect material on her as the spirit moved him. Cornell, then, was able to generate several collages out of this experience. Nevertheless, he was aware that the feelings animating the work were elusive and difficult to capture, "as though," he noted in his diary, "anything can be put down in such states as have characterized J[eanne]. E[agels]. 'flashes.'"[18]

In such light, *The Gift* comments ambiguously upon *How to Make a*

17. Diary entries, August 20, 21, 25, and undated (c. August) 1963, Cornell Papers, roll 1061, frs. 950-51, 964-65, 968.
18. Diary entry, August 25, 1963, Cornell Papers, roll 1061, fr. 964.

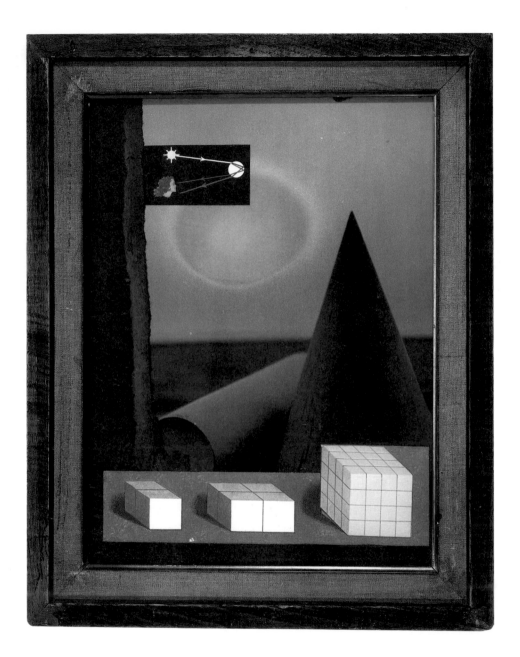

8. *Joseph Cornell*, How to Make a Rainbow (for Jeanne Eagels), *c. 1963-65, collage, 11-3/8 x 8-3/8 in. Photograph courtesy The Pace Gallery, New York.*

Rainbow. Both collages share the same brightly colored geometric landscape composed of a cone, sphere, and cylinder. At first glance, *The Gift* radiates sweetness and light. A little girl in a starched party dress and Mary Jane shoes holds a wrapped and ribboned box. Has she just received this present or is she on her way to a party? Is she a surrogate for Cornell or is she his emissary? In either possibility, Cornell associated this gift with childhood, innocence, and purity. Her presence suggests that giving is an act of spiritual rebirth. Yet this scene of enchantment becomes disquieting upon closer examination. The little girl's sash, tied in a rear bow, reveals not its starched ends stiffly outstretched, but a pair of disembodied arms whose hands tie or adjust her bow.

Another reading of these ambiguously placed hands suggests that the girl herself is an offering in a timeless landscape. She might well represent Jeanne Eagels, whom Cornell has restored to her lost childhood. In giving, this child becomes a gift, perhaps even suggesting an artist's gifts of creativity. This transformation is further intimated by the position of the arms, which seem to emerge from the cylinder, as though the child herself has emerged from a cosmic order to which she will return. The austerity of the landscape undermines the bright colors and dissipates the lyricism, as the girl seems caught up by impersonal cosmic forces. Gifts, especially artists' gifts, involve risky transactions. In this instance, Cornell's gift—the little girl's present, the little girl, the collage itself—might well be retracted, as suggested by the arms that can make or withdraw an offering. The possibility of loss reverberates throughout *The Gift* and suggests Cornell's preference for the "Jeanne Eagels flash" to the creation of a work that might or might not resolve his feelings, and in either case diminish the initial luminous moment. That Cornell could overcome such reservations suggests the strength of his generosity in offering his works as gifts.

Early Gifts from an
Enchanted Wanderer

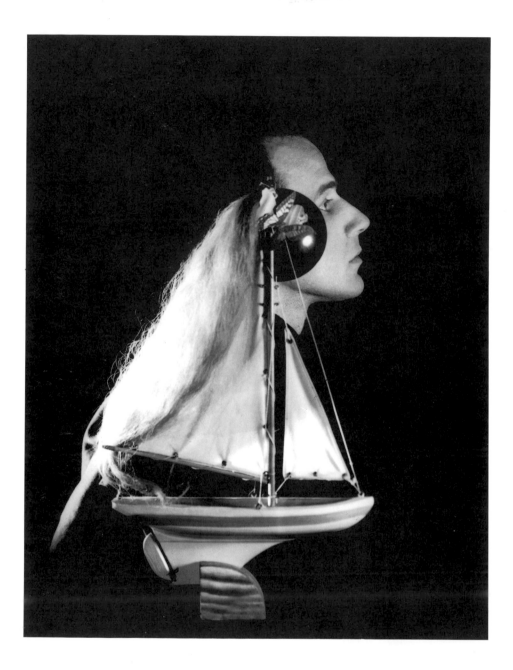

9. *Joseph Cornell, 1943-44. Photograph by Lee Miller Penrose.*
Courtesy the Lee Miller Archives, East Sussex, England.

\mathcal{J}ULIEN LEVY, THE LEADING IMPRESARIO of Surrealism in New York during the 1930s, recalled that Cornell sailed into his gallery one day with a toy boat under his arm. "I included this in the [first Surrealist] exhibition," in 1932, he claimed, "because he had tied the North Star to his mast and spun the wind like hair for the sails of his boat."[19] Levy's description of Cornell's nautical entrance into his gallery would have all the earmarks of a fanciful metaphor were his trope not tied to an actual image photographed by Lee Miller (pl. 9).

Levy introduced Cornell to Miller, a young American who had returned from the Surrealist environs of Paris to set up her own photography studio in Manhattan. Miller had broken off her affair with Man Ray, who had taken on the beautiful model as his assistant in his atelier. When Cornell met her, she had become an accomplished fashion photographer and would go on to record the horrors of the Second World War with her own Surrealist vision.

Cornell approached Miller for a sitting that through their collaborative effort became a self-portrait. Miller more than met the challenge he posed. Apart from her technical skills as a photographer, she brought to the project her close familiarity with Surrealism and the ways that its sensibilities might be photographically realized. Having collaborated previously with Man Ray, she was adept at combining portraiture and still-life. Her photograph of Cornell, a hybrid portrait, assemblage, and still-life, offers a dramatically lit profile of his serene face set against a schooner, its sails joined by a gossamer streamer, suggesting a woman's flowing hair.

Like many self-portraits of artists, this image made a statement about Cornell's creative affinities and aspirations. In echoing an image from Max Ernst's collage novel, *A Little Girl Dreams of Taking the Veil* (pl. 10), the young artist announced his independent adaptation of Surrealism. As a synthesis of voyager and ship, male and female, brought together in Cornell's ambiguous guise, this self-portrait had affinities with the androgynous imagery that existed

19. Julien Levy, "Joseph Cornell: or Twelve Needles Dancing on the Point of an Angel," in *Joseph Cornell Portfolio-Catalogue,* ed. Starr, np.

on the margins of the Surrealist group among women artists disaffected by its male domination and often violent if not misogynous images of women.

The artistic implications of this gender-doubling portrait of Cornell would become clearer in 1940, when he contributed to Charles Henri Ford's *View* magazine an "Excerpt from a Journey Album for Hedy Lamarr," which combined a verbal and visual homage to an "'Enchanted Wanderer.'" It was during the summer of 1941, he later recalled, that he went to The Metropolitan Museum of Art in New York to purchase a reproduction of a painting by Giorgione of a Renaissance youth with which he had a photographer make a flawless montage portrait of Lamarr for *View* (pl. 11). Cornell's longstanding interest in film was here expressed as adulation for the Hollywood stars. To his friend Parker Tyler, associated with *View,* Cornell confessed that he had seen Lamarr in *Come Live With Me* five times.[20]

The "'Enchanted Wanderer'" was no ordinary fan letter. In his idealization of Lamarr, Cornell fantasized her as a naïve and innocent androgynous being. "She has carried a masculine name in one picture," Cornell reminds us, "worn masculine garb in another, and with her hair worn shoulder length and gentle features like those portraits of Renaissance youths she has slipped effortlessly into the role of a painter herself . . . le chasseur d'images."[21] With these elisions of gender, Lamarr transcended apparent cultural dualisms to embody Old World and New, past and present, art and technology, high culture and low in Cornell's portrait.

20. Diary entry, "typed from memory," February 17, 1947, Cornell Papers, roll 1058, fr. 880: "Summer 1941. Unusually fine clear soft weather. Trip to the Metropolitan Museum of Art in connection with VIEW article "'The Enchanted Wanderer'"; Cornell to Tyler, May 25, 1941, Charles Henri Ford Papers, Harry Ransom Humanities Research Center, University of Texas at Austin, hereafter, Ford Papers, HRC.
21. Joseph Cornell, "'Enchanted Wanderer': Excerpt from a Journey Album for Hedy Lamarr," *View* 1, 9-10 (December 1941-January 1942), p. 3. Keller (p. 105) notes the androgyny of the Lamarr image: "To imagine her as an enchanted wanderer, a man, and an artist is to make her a surrogate for Cornell himself."

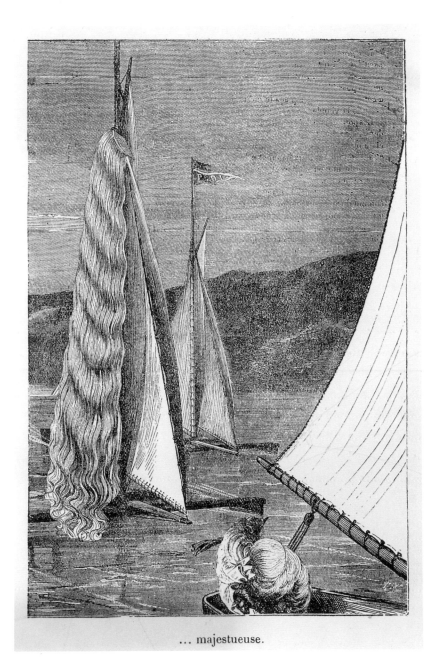

... majestueuse.

10. From Max Ernst, A Little Girl Dreams of Taking the Veil
(Réve d'une Petite Fille qui voulut entrer au Carmel. *Paris: Editions du Carrefour, 1930).*

"ENCHANTED WANDERER"

★ **Excerpt from a Journey Album for Hedy Lamarr** ★

By

JOSEPH CORNELL

★

Among the barren wastes of the talking films there occasionally occur passages to remind one again of the profound and suggestive power of the silent film to evoke an ideal world of beauty, to release unsuspected floods of music from the gaze of a human countenance in its prison of silver light. But aside from evanescent fragments unexpectedly encountered, how often is there created a superb and magnificent imagery such as brought to life the portraits of Falconetti in "Joan of Arc," Lillian Gish in "Broken Blossoms," Sibirskaya in "Menilmontant," and Carola Nehrer in "Dreigroschenoper?"

And so we are grateful to Hedy Lamarr, the enchanted wanderer, who again speaks the poetic and evocative language of the silent film, if only in whispers at times, beside the empty roar of the sound track. Amongst screw-ball comedy and the most superficial brand of clap-trap drama she yet manages to retain a depth and dignity that enables her to enter this world of expressive silence.

Who has not observed in her magnified visage qualities of a gracious humility and spirituality that with circumstance of costume, scene, or plot conspire to identify her with realms of wonder, more absorbing than the artificial ones, and where we have already been invited by the gaze that she knew as a child.

Her least successful roles will reveal something unique and intriguing — a disarming candor, a naivete, an innocence, a desire to please, touching in its sincerity. In implicit trust she would follow in whatsoever direction the least humble of her audience would desire.

*"She will walk only when not bid to, arising from her bed of nothing, her hair of time falling to the shoulder of space. If she speak, and she will only speak if not spoken to, she will have learned her words yesterday and she will forget them to-morrow, if to-morrow come, for it may not."**

(Or the contrasted and virile mood of "Comrade X" where she moves through the scenes

* Parker Tyler

like the wind with a storm-swept beauty fearful to behold).

* * * * * * * *

At the end of "Come Live With Me" the picture suddenly becomes luminously beautiful and imaginative with its nocturnal atmosphere and incandescence of fireflies, flashlights, and an aura of tone as rich as the silver screen can yield. Her arms and shoulders always covered, our gaze is held to her features, where her eyes glow dark against the pale skin and

her earrings gleam white against the black hair. Her tenderness finds a counterpart in the summer night. In a world of shadow and subdued light she moves, clothed in a white silk robe trimmed with dark fur, against dim white walls. Through the window fireflies are seen in the distance twinkling in woods and pasture. There is a long shot (as from the ceiling) of her enfolded in white covers, her eyes glisten in the semi-darkness like the fireflies. The reclining form of Snow White was not protected more

lovingly by her crystal case than the gentle fabric of light that surrounds her. A closer shot shows her against the whiteness of the pillows, while a still closer one shows an expression of ineffable tenderness as, for purposes of plot, she presses and intermittently lights a flashlight against her cheek, as though her features were revealed by slow-motion lightning.

In these scenes it is as though the camera had been presided over by so many apprentices of Caravaggio and Georges de la Tour to create for her this benevolent chiaroscuro . . . the studio props fade out and there remains a drama of light of the *tenebroso* painters . . . the thick night of Caravaggio dissolves into a tenderer, more star-lit night of the Nativity . . . she will become enveloped in the warmer shadows of Rembrandt . . . a youth of Giorgione will move through a drama evolved from the musical images of "Also Sprach Zarathustra" of Strauss, from the opening sunburst of sound through the subterranean passages into the lyrical soaring of the theme (apotheosis of compassion) and into the mystical night . . . the thunderous procession of the festival clouds of Debussy passes . . . the crusader of "Comrade X" becomes the "Man in Armor" of Carpaccio . . . in the half lights of a prison dungeon she lies broken in spirit upon her improvised bed of straw, a hand guarding her tear-stained features . . . the bitter heartbreak gives place to a radiance of expression that lights up her gloomy surroundings . . . she has carried a masculine name in one picture, worn masculine garb in another, and with her hair worn shoulder length and gentle features like those portraits of Renaissance youths she has slipped effortlessly into the role of a painter herself . . . le chasseur d'images . . . out of the fullness of the heart the eyes speak . . . are alert as the eye of the camera to ensnare the subtleties and legendary loveliness of her world. . . .

[*The title of this piece is borrowed from a biography of Carl Maria von Weber who wrote in the horn quartet of the overture to "Der Freischutz:" a musical signature of the Enchanted Wanderer.*]

11. Joseph Cornell, "'Enchanted Wanderer,'" View, 1941-42.

Inasmuch as Cornell considered himself a "hunter of images," he implicitly identified with Lamarr's transmutation of female into male into artist, thereby expanding his creative purview as an "enchanted wanderer." In this light, he would remain fascinated by the possibilities of double images, whose nuances of meaning appeared throughout his assemblage over the years. In 1948, for example, he would offer his own gift to Lee Miller by portraying the photographer doubled, suggesting her dual creative powers as a woman and artist (pl. 12). With her hair cut short, Miller's youthful double wears a masculine jacket, while in the foreground she is revealed as the stunningly beautiful woman that she was. In his photo-collage, set in a traditional oval frame with a delicate floral background, Cornell pays homage to an idealized Miller at the height of her career, bathed in an amber glow.

Cornell pursued his exploration of the female/male as artist and voyager into the 1960s with a collage known as *Ship with Nude* (pl. 13). He explicitly eroticized the image of a sailing vessel by pairing it with a female nude, her arm outstretched along the prow in the fashion of a figurehead. The deep blue tone and a display of constellations suggest a voyage toward cosmic horizons. The woman herself sensuously radiates a starry vision to guide the ship once it leaves port.

In a diary entry for November 16, 1963, Cornell juxtaposed a reference to this "collage figurehead" with Léonor Fini, a fiercely independent artist among the Surrealists in Paris. Cornell placed her name in quotation marks as though to emphasize the symbolic connection made between the image and the fiery young woman to whom he had paid homage in a collage of the 1930s. Fini's paintings often involved erotic self-portraiture and androgynous figures in strange landscapes. Her paintings appeared in New York, thanks to Julien Levy, who had visited her disorderly apartment in Paris to discover a woman with the "head of a lioness, mind of a man, bust of a woman, torso of a child, grace of an angel, and discourse of the devil." He was sufficiently impressed with this wilfully eccentric painter to exhibit her works with those of Max Ernst in November and December 1936. At the same time, a few of her works were shown at The Museum of Modern Art's large exhibition

"Fantastic Art, Dada, Surrealism."[22]

In the early part of 1937, Fini visited New York for four months. Escorted around by choreographer George Balanchine and Pavel Tchelitchew, the Russian émigré painter, she saw all the sights of the city, from Harlem to Minski's burlesque in lower Manhattan and Coney Island in Brooklyn. Although Cornell never met Fini, he knew of her through Tchelitchew, whose stories about her left a lasting impression. Some twenty years later he would note that a telephone call from Joella Bayer, Levy's former wife, transported him back to "the world of Max Ernst, Atget, Cartier-Bresson, Léonor Fini et al."[23]

In 1939, when thoughts of Fini were still fresh in his mind, Cornell thanked Charles Henri Ford for allowing him to read a then unpublished poem titled "Serenade to Léonor Fini" ("Lion-girl of the Rue Payenne"). Declining to collaborate with Ford at that time, Cornell recalled an earlier collage made up of materials provided by Fini through Tchelitchew and Tyler. "I gave Fini an 'homage' montage one time that I don't believe I could duplicate in a hurry," he wrote. "She gave me a drawing for it."[24] Although Cornell implies that Fini exchanged a drawing for Cornell's homage, in actuality she was unaware that he had incorporated her drawing into his collage.

The drawing at hand was based on *The Lost Needle,* a painting of a seated

22. Diary entry, November 16, 1963, Cornell Papers, roll 1061, fr. 1104; Julien Levy, *Memoir of an Art Gallery* (New York: G. P. Putnam's Sons, 1977), p. 170. Three of Fini's works, two paintings and a drawing, were in The Museum of Modern Art's exhibition in 1936: *Games of Legs in a Key of Dreams* (1935); *Argonaut* (1936), and *Personage* (1935) (*Fantastic Art, Dada, Surrealism,* ed. Alfred H. Barr, Jr. [New York: The Museum of Modern Art, 1936], cat. nos. 374-76, p. 270).

23. Correspondence fragment, October 7, 1957, Cornell Papers, roll 1060, fr. 475; Fini to the author, March 25, 1992. I am indebted to Whitney Chadwick, professor of art history at San Francisco State University, who told me that Fini in an interview, June 24, 1982, had recalled her trip to New York. Professor Chadwick also generously supplied the checklist of Fini's 1936 exhibition at the Julien Levy Gallery.

24. Cornell to Charles Henri Ford, January 30, 1939, Charles Henri Ford Papers, Special Collections, The Getty Center for the History of Art and the Humanities, Santa Monica, California, hereafter, Ford Papers, Getty Center. Ford published "Serenade to Léonor" in *Poems for Painters* (New York: View Editions, 1945), np.

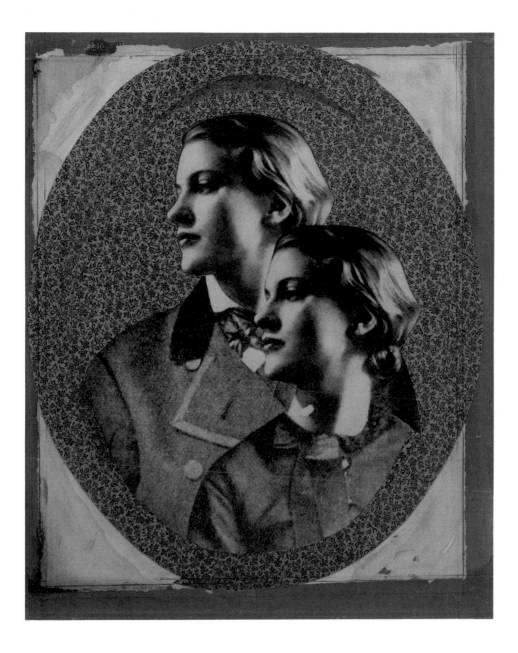

12. Joseph Cornell, Untitled (Portrait of Lee Miller), *c. 1948-49, collage, 11 x 9-1/4 in.*
Collection Vivian Horan, New York.

woman engaged in sewing that had been exhibited at Julien Levy's in 1936. This painting became all the more enigmatic and unsettling when Cornell paired a black-and-white reproduction of it in a collage with Fini's drawing, which depicts a woman half-blinded by a bandage or scarf (pl. 14). In striving for a subtle homage, Cornell simply "composed" her images in a rectangular mat, setting the reproduction of *The Lost Needle* above a photograph of Fini flamboyantly posed, and both flanked by the larger drawing. (In 1940 Cornell told Ford that Parker Tyler had given him a "little Fini" wearing a "striped dress," presumably the photograph in the collage.)[25] Underneath the drawing he collaged an inscription from Fini sending him warm regards. In the resulting ensemble, Fini is represented by her own artistic achievements, her own words, and her own persona as captured in the photograph. Cornell even avoided his usual manipulation and embellishment of borrowed images so that the picture of Fini that emerges in this atypical arrangement blurs the distinction between portraiture and self-portraiture.

Cornell's most sustained exchange among women associated with Surrealism took place with Dorothea Tanning, a young American painter whom he had met on the same gallery circuit. In April 1944 Julien Levy gave Tanning her first solo exhibition. For an accompanying catalogue brochure (which Cornell kept over the years), Max Ernst wrote a short appreciation of her works as "among the most authentic, most unfettered expressions of surrealism," despite her refusal to bow to Surrealist orthodoxy—a qualification that the independent Cornell must have appreciated.[26]

Ernst praised Tanning's ability "to paint an intimate and dramatized biography of the universe, the tumults of the child's soul, the mysteries of love." Such qualities, dramatically evident in the adolescent languors and

25. Cornell to Charles Henri Ford, January 14, 1940, Ford Papers, Getty Center.
26. Max Ernst, *Dorothea Tanning* (New York: Julien Levy Gallery, 1944), Cornell Papers, roll 1072, fr. 134. For a memoir of her life, see Dorothea Tanning, *Birthday* (Santa Monica and San Francisco; The Lapis Press, 1986). Also see Jacqueline Bograd Weld, *Peggy The Wayward Guggenheim* (New York: E. P. Dutton, 1986), pp. 294-98.

electric tension running through *Eine Kleine Nachtmusik,* also appealed to Cornell's sensibilities (pl. 15). Outside the galleries, Cornell had the opportunity to see this painting as well as *Birthday* and *Jeux d'enfants* in *VVV,* a Surrealist magazine edited in New York by André Breton, Duchamp, and Ernst during the Second World War.[27]

Tanning's relationship with Ernst and their subsequent marriage was signicant to Cornell, as it was Ernst's collages in the early 1930s that had provided the aspiring artist with the "Joy of discovery," recalled even years later.[28] Circumstances forced Cornell to sustain a long-distance relationship with Tanning. Having settled in Sedona, Arizona, in 1945, after first summering there in 1943, Tanning and Ernst then moved to France in 1948, making only intermittent trips thereafter to the United States. As a result, Tanning's correspondence with Cornell was often punctuated by postcards on the run, sending her love and affection. Due to their frequent moves he in turn missed opportunities to send her more elaborately designed letters.[29]

Because of the distance that separated them, their exchange of letters was all the more meaningful. Tanning made a virtue out of necessity. "Sometimes I think that the only true and satisfactory means of contact with those we love is by writing rather than talking," she wrote. "So it seems to me that our letters are far more the real barometer of our feelings than when we speak for a few overcharged moments in New York. Certainly you will agree that the atmosphere there, in most cases, is electric and artificial."[30]

By hinging her friendship on writing, however, Tanning occasionally felt

27. Ernst, *Dorthea Tanning.* Tanning also wrote "Blind Date," which preceded two illustrations of her paintings, *Birthday* (1942) and *Jeux d'enfants* (1942) in *VVV* 2-3 (March 1943), pp. 104-106. *Eine Kliene Nachtmusik* appeared in *VVV* 4, February 19, 1944, p. 57.

28. Diary entry, February 4, 1947, Cornell Papers, roll 1076, fr. 2.

29. Perhaps inspired by Tanning's enthusiasm for Arizona, Cornell was impressed by the "endless richness of landscape" in reading *Arizona Highways.* After laying out its collage possibilities, he added, "the above 'ARIZONA' aspect might have been developed by letter to Dorothea & Max in Arizona (like Matta in Italy) had it occurred sooner than only day before leaving" (diary entry, September 29, 1951, Cornell Papers, roll 1059, fr. 359).

30. Tanning to Cornell, March 3, 1948, Cornell Papers, roll 1055, fr. 509.

13. Joseph Cornell, Untitled (Ship with Nude), *mid-1960s, collage, 11-1/2 x 8-1/2 in.*
Collection Robert Lehrman, Washington, D.C.

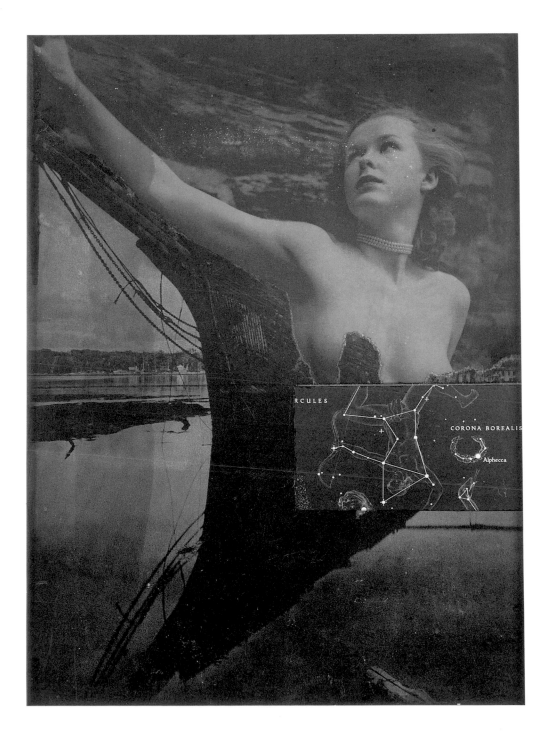

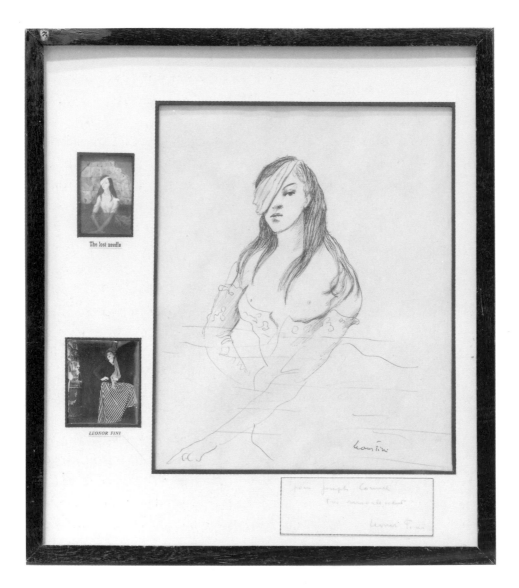

14. Joseph Cornell, The Lost Needle, *c. 1937, collage with drawing by Léonor Fini. 12-1/2 x 11 in.*
Lent to The Art Institute of Chicago by Lindy Bergman.
Photograph courtesy The Art Institute of Chicago.

blocked. Rather than mouth "some invented clichés" in place of a "poetic" correspondence, she explained to Cornell that she preferred to stay silent. Even so, she remained close in his reverie, as he jotted in his diary in 1946: "dream of D[orothea] in bare feet and saw-dust," a notation cryptically appended to a reminder to write Ernst. [31]

Cornell treasured Tanning's letters from the 1940s because of their illustrations, most likely in response to his own practice of transforming his letters with *papiers collés*. Gifts in themselves, these letters bore quick sketches of young girls, one of them emerging from behind a drape that dissolves into the written page. In his diary, Cornell noted finding her "beautiful letter" in the "morning mail," the drawing an "exquisite surprise," he exclaimed, "illustrating story of old Paris with jeune fille of the 1840s." In another letter, she collaged a young girl in Victorian dress, her face partly-hidden by a parasol, emblematic of the way that letters mediate between correspondents. Tanning illustrated her letter of October 6 [c. 1945], with a young girl surrounded by angel wings as though she is selecting a pair (pl. 16). Since this figure, labeled (signed?) "Dorothea," may be a self-portrait, perhaps this is a Dorothea "distract[ed]" from her "higher purpose" by "trivial" duties, as she indicated in her script flowing around the image.[32]

Cornell and Tanning also exchanged little presents—books and photographs that seemed to nourish their imagination. Knowing his interests, Tanning once asked Cornell for "a picture of a clipper ship, one of those corny ones generally seen reproduced on calendars." Beyond this request, she was really preoccupied with her artistic frame of mind, which she conveyed to Cornell with an air of urgency. She wrote of her struggle to achieve a "real clarity" in her letters—a struggle that extended into her "waking moments,

31. Tanning to Cornell, January 3, 1949, and diary entry, undated (probably 1946), Cornell Papers, roll 1055, fr. 783, and roll 1059, fr. 124.
32. Tanning to Cornell, April 29 [1948], Cornell Papers, roll 1055, frs. 602-603; diary entry, May 4, 1948, Cornell Papers, roll 1059, fr. 121; Tanning to Cornell, letter with collage, March 3, 1948, roll 1055, frs. 509-11; Tanning to Cornell, letter with angel drawing, October 6 [c. 1945], Cornell Papers, roll 1055, frs. 428-29.

with the problems of authenticity and value."[33] Those problems brought her and Cornell together in mutual support and consideration.

"My dreams, my illusory impressions and my waking life are all so mixed and confusing that I sometimes wonder if there is any reality at all," Tanning wrote in her letter of March 3, 1948. "It may sound foolish but it is my belief that there is only poetry and revulsion. I'd like to let the poetry in and keep the revulsion out." Cornell was her model. "That is something that you, of all the people I know, have somehow managed to do. How did you do that, Joseph?" she asked. As for her, she was too aware of the world. "Maybe that is your secret," she thought, "maybe that is what you keep out."[34]

Tanning may have turned Cornell into a sounding board for her own artistic struggles, but she also supported his efforts, encouraging him to "make another exhibition of those beautiful objects." Her support took a tangible turn when William Copley and his brother-in-law John Ployardt came from Los Angeles to visit Ernst and Tanning. The two young men had decided to open a gallery in Beverly Hills that would be devoted to Surrealism. Tanning wrote Cornell that "some nice lads from Hollywood came here last week . . . and were full of enthusiasm for your work. We all spoke of you, of your own special genius, of their plans for showing it to the west-coast public."[35]

Copley and Ployardt had already met Cornell in New York through a circuitous connection that ran from Man Ray, then living in Hollywood and recruited for a show at the new gallery, to Duchamp, who lived above a beauty parlor on Fourteenth Street in Manhattan. Duchamp in turn led the two neophytes to Alexander Iolas, whose Hugo Gallery on East 55th Street had shown Cornell's "Portraits of Women" in a "Romantic Museum" in 1946. "One day when we were in his gallery," Copley recalled, "a gaunt cadaverous Charles Adams-like character wandered in with a heavy paper shopping bag. . . . One

33. Tanning to Cornell, October 6 [c. 1945], and March 3, 1948, Cornell Papers, roll 1055, frs. 428, 509.
34. Tanning to Cornell, March 3, 1948, Cornell Papers, roll 1055, frs. 509-10.
35. Tanning to Cornell, October 6 [c. 1945] and April 29 [1948], Cornell Papers, roll 1055, frs. 429, 603.

15. Dorothea Tanning, Eine Kleine Nachtmusik, *1943, oil on canvas, 16-1/4 x 24 in.*
Private Collection, England.

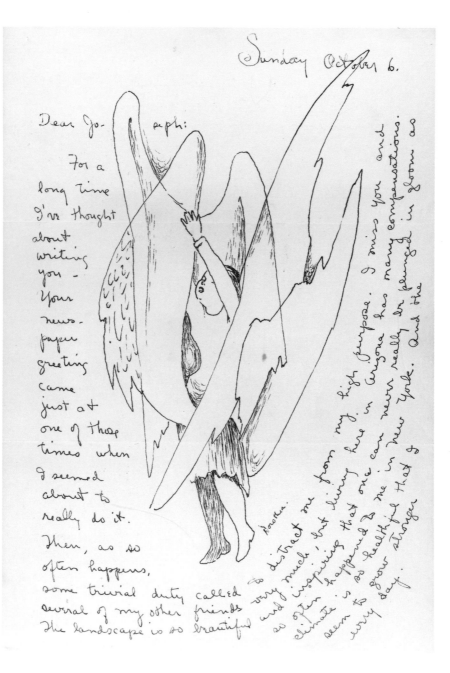

Sunday October 6.

Dear Jo- seph:

For a long time I've thought about writing you — Your news- paper greeting came just at one of those times when I seemed about to really do it.

Then, as so often happens, some trivial duty called several of my other friends The landscape is so beautiful

Dorothea.

to distract me from my high purpose. I miss you and very much, but living here in Arizona has many compensations. and inspiring that one can never really be penned in form as so often happened to me in New York. And the so healthful that so climate is seem to grow stranger every day.

16 a, b Letter from Dorothea Tanning to Joseph Cornell, October 6 (c. 1945).
Joseph Cornell Papers, Archives of American Art, Smithsonian Institution, Washington, D.C.

I had intended to come to New York for an exhibition in November but changed my mind and will now plan for March. Tell me, please, are you making some more of your beautiful things? I do wish you would make another exhibition-full of those beautiful objects, I can hardly think of anything that would delight me more to see. I think of you as a great artist, Joseph, and I believe that if you would just follow up with one more show of your work you would find that a great many people feel about them as I do. And I know they would sell.

As you probably know by now, I was very ill last winter and my legs are still somewhat affected. But they are getting better, slowly but positively. So I am very thankful.

I do hope you are well and in a good mood. Please write to me when you can. Max sends best wishes.

Affectionately, Dorothea.

17. Dorothea Tanning, 1945. Photograph by Robert Motherwell.
Courtesy Cavaliero Fine Arts, New York.

after another, he arrayed a floor full of magical toy-like boxes, each one quite a wonder." It was, of course, Cornell.[36]

The California Cornell show, which opened on September 28, 1948, was a "fiasco"; nothing sold, and Cornell blamed Copley and Ployardt for overpricing the work. Tanning tried to console Cornell by noting how fortunate they were to have friends who appreciated their work. She was to have a show at the Copley Galleries in March 1949. "I am putting together a catalogue of reproductions and some poems and poetic comments by my friends," she wrote. "I would be so happy, Joseph, if you felt inclined to make a little

36. William Copley, "Portrait of the Artist as a Young Art Dealer," in *CPLY: Reflection on a Past Life* (Houston: Institute for the Arts, Rice University, 1979), p. 14.

contribution along this line. For I in turn feel that you have a special insight into my pictures."[37] Cornell's understanding of her work is evident in a diary entry describing one of his frequent commutes on the Long Island Railroad. Cornell noted "the dramatic early afternoon light," which provided a "real aura of magic," reminding him of earlier trips "in a more difficult state of mind" when a heightened "drama" triggered "Dorothea Tanning's world suggested in her paintings."[38] The tension he sensed in her works corresponded with his own emotional state.

It was hardly coincidence that these three women artists with whom Cornell engaged in exchanges were, like himself, on the fringes of Surrealism. At the same time, they were courageous artists who dared to declare their own independence. Their very lives offered lessons of autonomy: Miller, by breaking with Man Ray and forging her own career as a photographer; Fini, by refusing to join the Surrealist movement in the first place; and Tanning, perhaps most of all, by striving for her own artistic authenticity.

The brief encounters and intermittent exchanges with these artists in the 1930s and early 1940s foreshadowed subsequent patterns of gift exchange that Cornell would enjoy. Despite the disconnections, both deliberate and circumstantial, he managed to make the most out of his contacts. His self-portrait with Miller signals an artistic identity as a voyager who would gather both men and women into his assemblage. His collaboration with Fini points to the artist at the center of assemblage, one whose presence is in the work. And his exchanges with Tanning reveal a mutual generosity, a desire to expend their gifts in support and encouragement.

37. Copley, p. 22; Tanning to Cornell, January 3, 1949, Cornell Papers, roll 1055, fr. 783.
38. Diary entry, December 8, 1948, Cornell Papers, roll 1059, fr. 157.

Cornell's "Inspired By-Paths of Romance": Marianne Moore and Emily Dickinson

18. Marianne Moore, 1935. Photograph by George Platt Lynes.
Courtesy Marianne Moore Archives, The Rosenbach Museum and Library, Philadelphia.

\mathscr{A}LTHOUGH CORNELL DID NOT BEGIN his correspondence with Marianne Moore until the spring of 1943, he would have known of the poet's distinguished tenure as editor of *The Dial* during the 1920s, when he had turned to its pages for a distillation of modern art and poetry. Circumstances brought the two closer together when Cornell's friends Charles Henri Ford and Parker Tyler had eagerly courted her for *View*, a new poetry tabloid that Ford began on the eve of World War II. Tyler interviewed this "glamorous literary legend" for *View* in New York's Grand Central Station between the poet's appointments.[39]

Unaware that Moore had attended the large survey of Dada and Surrealism at The Museum of Modern Art during the winter of 1936-37, Tyler seemed surprised to discover that this proper woman wearing an "ageless" hat and a blue suit found some "merit" in Surrealism.[40] Though instrumental in sustaining the high (and high-minded) modernism of *The Dial*, she was not above the subversions of the most recent avant-garde. After all, in joining forces with Ezra Pound and William Carlos Williams during the First World War, she had helped to change the course of American poetry. Still open to new talent twenty years later, she had responded enthusiastically to the show at The Museum of Modern Art by writing an informal appreciation of its exploratory spirit.

As a writer, Moore understandably was attracted to the literary nature of Dada and Surrealism, especially "the prevalence of innuendo and humor, effected often by paradox and the pun." And as a poet of visual precision, she appreciated a craftsmanship that was everywhere in evidence despite the anti-art thrust of these avant-garde movements. But above all, as a poet who remained independent of avant-garde coteries, she noted how Dada and Surrealist anarchism subverted the very movements themselves, such that an "artist develops away from the standard and thrives because he cannot conform."[41]

39. Parker Tyler, "Marianne Moore's Views on Writing and Editing," *View* 1, 3 (November 1940), pp.2-3.
40. Ibid.
41. Marianne Moore, "Concerning the Marvelous," 1937, pp. 1-2, unpublished ms., Library, The Museum of Modern Art, New York.

Although Moore omitted Cornell's large display, "The Elements of Natural Philosophy" and Soap Bubble Set, from her unpublished survey of the exhibition, the stage was set for their eventual correspondence: she with a keen appreciation for the visual, he with a voracious appetite for books. While both were attuned to Surrealism, each preferred to take an independent course as an avant-garde artist. Their exchanges in the 1940s would affirm the importance of art and civilized discourse during the height of barbaric destruction inflicted by the Second World War.[42]

When Ford asked Moore for a contribution to an issue of *View* on "Americana Fantastica" that Cornell was organizing, the poet demurred, but remained alerted to the issue when it appeared in January 1943. She was especially taken by Cornell's contribution, "The Crystal Cage (portrait of Berenice)," an elaborate construct of words and images in the shape of a tower (pl. 19). This Apollinairean collage celebrated a fictive little girl's immersion within a wide range of American and European lore. Ford relayed Moore's praise to Cornell, who wrote a letter of thanks on behalf of "Berenice," his precocious heroine.

"Dear Miss Moore," Cornell wrote on March 23, 1943, "The words in your note to Charles Henri Ford about 'the detaining tower' in the Americana Fantastica number of VIEW are the only concrete reaction I've had so far, and they satisfy and affect me profoundly" (pl. 20). His attempt to organize a cornucopia of material within the linear confines of a magazine had been both challenging and frustrating—and no less so for a reader, who perhaps would

[Handwritten margin note: Berenice Abbot?]

42. For a description of Cornell's display, see Dawn Ades, "The Transcendental Surrealism of Joseph Cornell," in *Joseph Cornell,* ed. McShine, p. 20, fig. 5. Cornell was able to express a larger context for his apparent lack of productivity: "When I think of the unspeakable things that have been visited upon so many countless thousands during the same period of time," he wrote, "I don't have many misgivings about not having 'produced' more" (Cornell to Moore, May 30, 1945, V:12:11, Moore Archives). For an assessment of Moore's relation to the visual arts, see Bonnie Costello, *Marianne Moore: Imaginary Possessions* (Cambridge and London: Harvard University Press, 1981), pp. 186-214; for her visual sources, see Patricia C. Willis, *Marianne Moore: Vision into Verse* (Philadelphia: The Rosenbach Museum and Library, 1987).

19. Joseph Cornell, "The Crystal Cage (portrait of Berenice)," View, January 1943.

The words in your note to Charles Henri Ford about " the detaining tower " in the Amer-
icana Fantastica number of VIEW are the only concrete reaction I've had so far, and
they satisfy and affect me profoundly. I had felt that the whole thing was much too
subtle and complex to attempt in the comparatively limited space of a magazine, and
without your appreciative words I would continue to think of it as futile. Will you
please accept the heartfelt thanks of both Berenice and myself? * * * The handwritten
correction of a phrase in your note was especially interesting as it confirmed a sus-
picion formulated nine years ago when I acquired in a second-hand book shop a number
of CLOSE-UP containing your review of documentary films in an article called " Fiction
or Nature ". This published article was corrected like proof in handwriting of such
exquisite precision and delicacy that it gave me the feeling that it belonged to it's
author. Later when I came to know of Parker Tyler's obsession with Carlyle Blackwell
and your work I quoted the passage to him about that actor in your article. * * * *
Speaking of natural history there are a couple of volumes from the library of the tower
that its little proprietress is taking the liberty of sending on to you in partial pay-
ment for your appreciation. She has marked a couple of spots that she greatly hopes
will be of outstanding interest to you.

 Very sincerely yours,

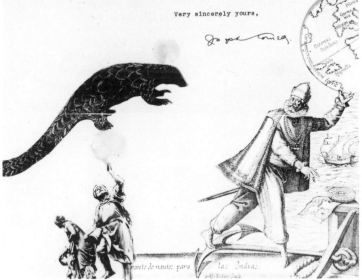

20. Letter from Joseph Cornell to Marianne Moore, March 23, 1943.
Photograph courtesy Marianne Moore Archives, The Rosenbach Museum and Library, Philadelphia.

have been better served by the flexibility offered by a portfolio. "Without your appreciative words," he confessed, "I would continue to think of it as futile." Confident of a sensitive reader, he boldly asked, "Will you please accept the heartfelt thanks of both Berenice and myself?"[43]

Cornell sustained this fiction in his concluding gesture: "Speaking of natural history there are a couple of volumes from the library of the tower that its little proprietress is taking the liberty of sending to you in partial payment for your appreciation. She has marked a couple of spots that she greatly hopes will be of outstanding interest to you." Cornell had already deferred to Moore's poetic interest in natural history with a fanciful collage decorating the letterhead as well as the lower margin, where it extended to the back of the blue writing paper.[44]

Promptly replying on March 26, the poet responded generously to "Mr. Cornell" by acknowledging the gift of his art as well as the presents at hand: "The pleasure given me by work of yours at the Museum of Modern Art, and at the Julien Levy Gallery when it was on Madison Avenue, are so great a gift it is scarcely just that these present gifts should be added."[45] What tonic for Cornell, keenly sensitive to his artistic isolation, that this poet was familiar with his work beyond the pages of *View.*

Moore's acknowledgment of Cornell's work was surpassed by a gift of her own in precisely describing the collage that adorned his letter: "The self-curling live juggler's ball on the head of the pangolin, and the armadillo's octagonned

43. Cornell to Moore, March 23, 1943, V:12:11, Moore Archives. Ford wrote to Moore for a poem on October 31, 1932, Moore Archives. Cornell's "The Crystal Cage (portrait of Berenice)" appeared in *View* 2nd series, 4 (January 1943), pp. 10-16 (tower on p. 11).

44. Cornell to Moore, March 23, 1943, V:12:11, Moore Archives. In this letter, Cornell also referred to Moore's survey of documentary film in "Fiction or Nature," *Close Up* 10 (September 1933), pp. 260-65, reprinted in *The Complete Prose of Marianne Moore,* ed. Patricia C. Willis (New York: The Viking Press, 1986), pp. 302-308. In the essay Moore was taken by the animals that appeared in the documentaries she reviewed. Because of his interest in film, which extended to film-making, Cornell remembered her essay and hence would have recalled her interest in natural history.

45. Moore to Cornell, March 26, 1943, V:12:11, Moore Archives.

damascened coat are not more of an armorer's dream than the way in which you have shaped the claws of the pangolin." With touch came greater pleasure: "And the whole when held to the light, with moon and stars added, forms a Bali shadow picture that Berenice might indeed have hesitated to part with." Not only did she enter into the fiction of Berenice, she must have won Cornell's heart by seeing "the maroon label for Volume II [of the natural history] with ovoid stars and gold garlands" as "in keeping with Berenice."[46]

What is delightful in this exchange was the way that artist and poet playfully added to each other's work. Cornell's collage alluded to Moore's "Pangolin" of 1941:

> Another armored animal—scale
> lapping scale with spruce-cone regularity until they form
> the uninterrupted central
> tail-row! . . .

She in turn graciously claimed, "My pangolin is reincarnated beyond itself in your juggling scene."[47]

Out of this initial exchange, in which both generously extended their talents in anticipation of the other's pleasure, flowed a correspondence of mutual criticism and support that lasted for several years. Cornell's first letter and Moore's response set the tone. Exercising a formal gravity, but never pretentious, they met as equals on the common ground of their art. Both understood and practiced a dictum that Moore had carefully inscribed in her 1939 diary: "A gift well received is a gift in return."[48]

Moore's response to Cornell's gifts reinforced his practice of attaching whimsical images to his letters. At the bottom of a letter on April 9, 1944, he

46. Moore to Cornell, March 26, 1943, V:12:11, Moore Archives.
47. "The Pangolin," originally published in *The Pangolin and Other Verse* (1936), reprinted in *The Complete Poems of Marianne Moore* (New York: The Macmillan Company and The Viking Press, 1972), pp. 117-20; Moore to Cornell, March 26, 1943, V:12:11, Moore Archives.
48. Diary entry, January 14, 1939, Conversation Notes, 1935-52, 1969, V:II:04:03, Notebook 1251/1 (1935), Moore Archives.

glued a cutout of a habitat case for birds. Characteristically enough, the image illustrated an article describing a child's tour among *cabinets de curiosités*. A year later, on May 30, 1945, he glued blue packets containing cutouts of animals on the left and top margins of his letter. A giraffe, a jerboa, and a sparrow hawk were among other creatures that Cornell knew Moore would enjoy. She would have immediately recognized the jerboa as Cornell's allusion to her poem about "a small desert rat, / and not famous, that / lives without water," from her *Selected Poems* of 1935.[49]

Cornell continued to send Moore gifts: another old book intended as a belated "Valentine package" along with an old sheet of paper "for a lady who may appreciate exquisite 'worm-work'" in 1944; later, some more paper for its watermarks. In her response, Moore recognized a plenitude beyond "this heap of treasure" in "the glamour of the illusory in your exhibition" at Julien Levy's gallery, which she must have attended during its run in December 1943. She also praised his selection of gift books as "inspired by-paths of romance," a phrase that he took for himself as delineating his own feelings and perceptions in his work.[50]

With such rapport so clearly established by 1945, Cornell felt comfortable in asking the poet to write a recommendation on his behalf for a John Simon Guggenheim Memorial Fellowship. Though she conceded a "lack of finish" to his proposal, she dryly thought that "the lack of Harvard and Oxford could be pardoned." Moore also noted that his anomalous situation was engendered by an artistic integrity that cost him money and prestige. Yet she praised him as "a virtuoso . . . incurably instinctively sensitive to the materials of his craft." His assemblage, she claimed, had "a poetic associative

49. Cornell to Moore, April 9, 1944, V:12:11, and May 30, 1945, V:12:11, Moore Archives; "The Jerboa," reprinted in *The Complete Poems of Marianne Moore*, pp. 10-15 (quotation on p. 13).
50. Cornell to Moore, April 9, 1944, V:12:11 and November 1, 1946, V:12:11; Moore to Cornell, April 11, 1944, V:12:11, Moore Archives. Cornell was in a group show, "Through the Big End of the Opera Glass: Marcel Duchamp, Yves Tanguy, Joseph Cornell," Julien Levy Gallery, December 7-28, 1943.

force hard to rival," offering, finally, "a kind of initiation in originality," her highest accolade.[51]

On his part, Cornell responded enthusiastically to Moore's poetry. She sent him a copy of *Nevertheless* when it was published in late September 1944. In two weeks time he acknowledged her "recent sheaf of poems," which he found "exquisitely and rightly proportioned." In an offering of "staccato or 'newsreel' reactions," his comments ranged from praise for her "transcendent craftsmanship" in "A Carriage from Sweden," to a memory of "Houdini making an elephant disappear on the old Hippodrome stage" triggered by a reference to the magician in "Elephants." Later, with her poems still echoing in his head, he would write to thank her for "the reminder that 'the mind is an enchanting thing' [as her poem was titled] . . . and that 'it is a power of strong enchantment.'"[52]

Despite so much in common, and an occasional visit in her apartment in Brooklyn, the two generally kept their distance, even when engaged in a common project. Known for his large cache of ballet material, Cornell designed many of the covers of *Dance Index,* the magazine founded by Lincoln Kirstein in 1942. As a consequence, he avidly read Moore's essay on Anna Pavlova in the March 1944 issue. As she had with Cornell's collaged letters, she brought her discerning eye to bear upon photographs of the legendary ballerina, who, seated on a lawn, displays a "descending line of the propped forearm, of her dress and other hand, of ankle and foot, continues to the grass with the naturalness of a streamer of seaweed."[53]

Impressed by her "quintessential words on Pavlova," Cornell invited Moore to contribute to an issue of *Dance Index* that was "all the work of his

51. Moore to the John Simon Guggenheim Memorial Foundation, September 19, 1945, V:12:11, Moore Archives. Despite Moore's recommendation, Cornell did not receive a fellowship.
52. Cornell to Moore, October 17, 1944, V:12:11, and November 1, 1946, V:12:11, Moore Archives. The poems in *Nevertheless* are republished in *The Complete Poems of Marianne Moore*, pp. 125-38.
53. Marianne Moore, "Notes on the Accompanying Pavlova Photographs," *Dance Index* 3, 3 (March 1944), p. 49 (photograph on p. 42).

hands, eyes and imagination," as Kirstein announced in a prefatory "Comment." The June 1946 issue, with Cornell's wonderful collaged reproduction of Georges Seurat's painting *Le Cirque,* of a circus equestrienne bursting through the cover, was "dedicated to those persistent dancers, the Clown, the Elephant and the Ballerina (or Equestrienne)" (pl. 21).[54] Cornell's exploration of dance in popular culture was taken up in this issue by Moore's appreciation of the "Ballet des Eléphants," which had been choreographed by George Balanchine for the Ringling Brothers-Barnum and Bailey Circus in 1942.

Recalling this "pageant of fifty elephants," the poet noted "their deliberate way of kneeling, on slowsliding forelegs . . . [as] fine ballet." She concluded by describing a female Javanese dancer whose photograph accompanied her remembrance: "Swirled aloft on the elephant's trunk, Vanessa with a confidence in his skill that was unanimity, had the security of a newt in the fork of a tree,—the spiral of the elephant's trunk repeating the spirals of the dancing: a moment of magnificence (pl. 22)."[55] Thus Moore joined the exotic with high and low culture in a way that must have satisfied Cornell's vision for this issue.

By the second year of their correspondence, Cornell felt that he had found a kindred spirit in Moore. In a letter of June 21, 1944, he told her about working in a defense plant for five months during the summer of 1943. Not the mundane labor of the factory, but "an account of a private zoo passed daily on my way to work" on the elevated train stood out in his mind. "Every morning," he wrote, "it gave me such a profound feeling of consolation against the pressure and 'claustrophobia' of the approaching daily routine that I could only think that Miss Moore was the *only other person in the world* who could ever appreciate the birds and animals of a zoo to such an extent."[56] Whether or not this "private zoo" actually existed is rendered moot by the importance it assumed in Cornell's imagination.

54. Cornell to Moore, June 21, 1944, V:12:11, Moore Archives; and Lincoln Kirstein, "Comment," *Dance Index* 5, 6 (June 1946), p. 135.
55. Marianne Moore, "Ballet des Eléphants," *Dance Index* 5, 6 (June 1946), p. 148.
56. Cornell to Moore, June 21, 1944, V:12:11, Moore Archives.

21. Joseph Cornell, cover for Dance Index, *June 1946.*

Cornell finally considered the poet among the select who understood his art. Writing in November 1946, he told Moore about a forthcoming exhibition of his "boxes and arrangements" at the Hugo Gallery. She kept the brochure announcing his "Romantic Museum," comprised of "Portraits of Women." Always reluctant to sell his work indiscriminately, he was comforted that she would be able to see the show. "One of the things that reconciles me to parting with the OWLS that will be there," he wrote, "is that eyes like your own may glimpse them before dispersal."[57]

Cornell had been making boxes containing birds since 1941; he called them "aviaries," variations on Victorian habitats of stuffed creatures. At mid-decade, he had turned to owls, such as *Untitled* (pl. 23), or the *Owl with Moon* (c. 1945), the latter wired to light up, increasing the verisimilitude of its habitat, a naturalism that he had admired upon first viewing the bird displays at New York's Museum of Natural History in 1941. Cornell's preoccupation with this motif culminated in an exhibition titled "Aviary by Joseph Cornell" at the Egan Gallery, in New York, that opened in December 1949. Knowing her keen interest in natural history, he had thought of asking Moore to write a foreword for the checklist of the exhibition. But, as he explained to her after the event, his "bird boxes" were "drawn together" at the last moment, so that it became "an awkward business to approach" her.[58]

This missed opportunity (Donald Windham filled in with a written appreciation) signaled a gradual divergence between Cornell and Moore, brought on by the circumstances of their personal lives. Yet her absence was more apparent than real. Cornell last wrote to her when her translation of La Fontaine's *Fables* was published in 1955. And as late as the 1960s, Cornell

57. Cornell to Moore, November 1, 1946, V:12:11, Moore Archives.
58. Cornell to Moore, February 15, 1950, V:12:12, Moore Archives. In his diary, July 15, 1941 (Cornell Papers, roll 1058, fr. 881), Cornell wrote: "Wandered around downstairs [in the Museum of Natural History] and noticed (also for the first time) the breath-taking collection of birds' nests in their original condition complete and replete with eggs."

22. Photograph of a Javanese dancer, Dance Index, *June 1946.*

cherished her phrase about "inspired by-paths of romance."[59]

The "Aviary" exhibition at Egan took Cornell from one poet to another on one of those inspired by-paths. Just as Moore had sustained him during the 1940s, Emily Dickinson would capture his attention during the early 1950s. And just as Marianne Moore was in some ways one of Emily Dickinson's heirs, so Cornell's movement into the past was less a retreat from the present than a retrieval of Dickinson's life for his own work through an act of homage and imaginary collaboration.[60]

Dickinson was an enigmatic figure, a poet who published little during her lifetime, a woman who in her early thirties deliberately became a virtual recluse. Only after her death in 1886 did her sister Lavinia come to realize the extent of her writing, discovering in her bedroom caches of poetry scrawled on bits and snippets of paper (much as Cornell scribbled his own diary entries) collected in small packets.[61] Publication of Dickinson's works proceeded slowly, as did the realization that a major American poet of the nineteenth century had lived unrecognized in Amherst, Massachusetts.

Cornell had first become acquainted with Dickinson through the painter Marsden Hartley, who devoted a chapter to her in his *Adventures in the Arts*, written in 1921, when the American avant-garde, under the enthusiasms of Dada, was turning to its indigenous culture. Hartley called the poet a local genius and, more crucially for the young Cornell, described her as a "magician in sensibility." Later, Cornell read Genevieve Taggard's *The Life and Mind of Emily Dickinson*, a full-length biography in contrast to Hartley's terse but apposite appreciation. Taggard claimed to discern a "double" Dickinson, a

59. Cornell to Moore, September 28, 1955, V:12:12, Moore Archives; diary fragment, 1960s, Cornell Papers, roll 1061, fr. 1241.

60. Cornell owned a copy of *Poetry in Our Time* (Garden City, New York: Anchor Books, 1963), by Babette Deutsche, who claimed Dickinson was Moore's "literary ancestor" (p. 100). The book was in Cornell's library (box 84, Cornell Papers).

61. Ashton, pp. 38-47, draws extensive parallels between Cornell and Dickinson in terms of their behavior and attitudes, as does Sandra Leonard Starr, *Box Constructions & Collages by Joseph Cornell* (Tokyo: Gatodo Gallery, 1987), pp. 27-29.

woman whose outer life was restricted by circumstance while her inner life was bound by "an esoteric chart" that resulted in the poetry.[62]

Reading *The Riddle of Emily Dickinson* by Rebecca Patterson renewed Cornell's interest in the poet during the fall of 1952. Despite a rhetoric that Cornell would have found attractive, neither Hartley nor Taggard had prepared Cornell for Patterson's solution to Dickinson's "riddle." Hartley referred to the poet as "that remarkable girl," a description possibly preferable to spinster, but one that attributes a perpetual adolescence if not asexuality to Dickinson. Taggard conventionally attributed the poet's retreat from Amherst society to contretemps and disappointments among suitors.[63] She was but among the first literary historians to speculate about a possible male interest for Dickinson.

Patterson boldly argued that Dickinson's seclusion and subsequent outburst of poetry in the early 1860s was motivated by her love for Catherine (Kate) Scott Anthon, a schoolmate of Sue Gilbert, who had married Dickinson's brother, Austin, in 1856. Kate Scott, then a young widow who eventually remarried, first visited Sue and Austin in March 1859 at their home next to the Dickinson mansion. Kate soon became Emily's close friend, replacing Sue, who before her marriage to Austin had stood first in the poet's affections.

Lest their declarations of love be construed simply as Victorian platonic rhetoric, Patterson claimed that Emily and Kate spent at least one night together. Patterson believed that when Kate grasped the implications of their affair, and the virtual impossibility of a sustained lesbian relationship in

62. Marsden Hartley, *Adventures in the Arts: Informal Chapters on Painters, Vaudeville, and Poets* (New York: Boni and Liveright, 1921), pp. 201, 203; Genevieve Taggard, *The Life and Mind of Emily Dickinson* (New York and London: Alfred A. Knopf, 1930), p. 252. Cornell, in a diary entry in 1953 (Cornell Papers, roll 1059, fr. 646), typed out a provocative passage in which Taggard compared Dickinson and Thoreau (ibid., pp. 249-50). With his love of acrobats and circuses, Hartley came to Cornell with the proper credentials. Cornell claimed "an eternal debt of gratitude" for Hartley's "beautiful and highly sensitive book of appreciations" (Cornell to Huth, July 20, 1953, Cornell Papers, roll 1059, fr. 833). Cornell consulted around a dozen sources on Dickinson before completing his projects on the poet.
63. Hartley, p. 198; Taggard, p. 289.

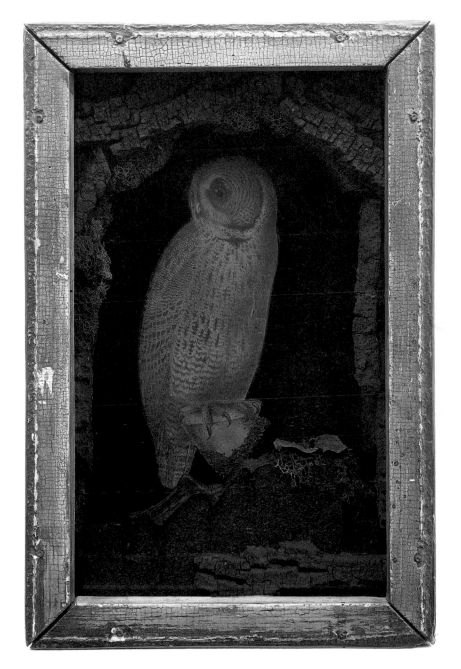

23. Joseph Cornell, Untitled, *c. late 1940s, mixed-media construction, 13 x 9-1/2 x 4-1/2 in. Photograph courtesy The Pace Gallery, New York.*

provincial New England, the more sophisticated woman felt constrained to withdraw. Anguished and bewildered, Dickinson subsequently poured her feelings into her poetry, which increased dramatically in the early 1860s.[64]

Patterson's theory would have been startling not only to Cornell, but to critics and scholars who by the 1950s were claiming the poet for the academy. Cornell was moved by Patterson's "new evaluation," as he put it, to reread Dickinson's poetry. The timing of this resumption was exquisite, for Cornell came to associate the experience of reading her poetry with Indian summer, his favorite time of year, which offered a momentary and hence poignant respite from the advent of winter. Cornell even expressed a heady feeling of intoxication "resembling the mood of her [poem] 'tippler in the sun,'" while fabricating his boxes, energized as he had been in preparing his Aviary exhibition at Egan a few years earlier.[65]

Meditating on Emily Dickinson early one morning in his kitchen, Cornell responded to the poet's "torturous seclusion" and intense immersion

64. Rebecca Patterson, *The Riddle of Emily Dickinson* (Boston: Houghton Mifflin, 1951), p. 179, succinctly summarizes the development of their relationship: "In March, 1859, the two young women undoubtedly met for the first time and were strongly attached to each other. In August, 1859, they recognized that their attraction was love. During a visit of late February or early March, 1860, a growing passion and the opportunity of spending a night together precipitated a situation which was bound to terrify both women. If Kate returned in July, 1860, with a proposal that they find some way of sharing their lives—but what could she propose? Neither woman had any money or independence."

Critics generally gave Patterson a drubbing for her circumstantial evidence, though the proof for a male lover remains equally circumstantial. Thomas H. Johnson, who would edit the poems and the letters, was the most generous in suggesting that Patterson at least placed a new emphasis upon Kate Anthon, who had been ignored among previous literary historians and biographers ("Kate Scott and Emily Dickinson," *The New York Times Book Review,* November 4, 1951, pp. 3, 34).

65. Diary entries, October 4 and 6, 1952, Cornell Papers, roll 1059, frs. 588, 593. Cornell wrote that these "poems had laid dormant in attic (except for DANCE INDEX) years and years. Taken for granted too much as a poet but this is a miserable excuse." Cornell found some consolation, however, in having read the first volume of her poetry "religiously in Bayside upon acquisition" (diary entry, October 4, 1952, Cornell Papers, roll 1059, fr. 588). Dickinson's poem "I cannot dance upon my toes" was published in *Dance Index 3,* 7-8 (July-August, 1944), p. 104, an issue based on Cornell's ballet material.

in her books subsequent to Kate Scott's rejection. He found new significance in her poem "Unto my books so good to turn," and ascribed analogous feelings to his own youthful experiences in escaping from the drudgery of his first jobs. Understandably, then, Cornell's interest in Dickinson took him to the book stalls of lower Manhattan, where in drifting over to Ninth Street, he discovered Emily Dickinson's daguerrotype in *Ancestors' Brocades,* a study of the poet written by her niece, Mabel Loomis Todd. Her image stayed with him, he later noted, against the urban backdrop of Manhattan at night. [66]

During the following April of 1953, Dickinson even entered Cornell's dreams, as he revealed in a scrawled diary entry: "dream of looking at reprod. of phot. of *Emily Dickinson* in book—dress as tho white blouse ca. 1914 ringletted coiffure (sharply detailed) large close-up of head-shoulders—the picture seemed to come to life (or be alive/real life) & eyes look toward spectator slightly but go back to position 3/4 turned away." Cornell felt a "friendly atmosphere" in contrast to the austere photographs in *Ancestors' Brocades.*[67]

Cornell's sympathy for Dickinson was fueled by Patterson's interpretation, which served as the basis for the boxes that he made for Dickinson during this period. For his two prototypes, Cornell borrowed formats that he had used exploring the aviary motif for his 1949 exhibition at Egan. The shift was not far-fetched, inasmuch as the poet occasionally referred to herself as a "little wren." The first, titled *Toward the "Blue Peninsula" (for Emily Dickinson)* (pl. 24), displays an empty aviary; it represents an implied continuation of Cornell's dream portrait, in which Dickinson is almost completely turned away (in contrast to the actual daguerreotype, which displays her frontally). The box provides an austere setting, characterized by a vertical geometry punctuated by horizontal bars that serve as perches. The door to a wire mesh

66. Diary entry, October 10, 1952, Cornell Papers, roll 1059, fr. 588. "The impact in these surroundings the scene of so many countless browsings and starting for home via subway—the crowds, the lighted cars in winter, the lighted skyscrapers across the water—unconsciously the background of all this for the E.D. photograph" (diary entry, October 30, 1952, Cornell Papers, roll 1059, fr. 603).
67. Diary entry, April 24, 1953, Cornell Papers, roll 1059, fr. 724.

24. Joseph Cornell, Toward the "Blue Peninsula" (for Emily Dickinson), *c. 1953, box construction, 14-1/2 x 10-1/4 x 5-1/2 in. Collection Robert Lehrman, Washington, D.C.*

cage is ajar; on the rear wall a window opens to an empty blue sky.

Emily Dickinson, then, has flown the coop, though she has left behind a sign of her presence in the title's allusion to one of her poems, written around 1862. The poem moves by paradox ("It might be lonelier / Without the Loneliness") through the seclusion of the narrator's "little Room," to the possibilities of hope and then, in the final stanza, out to sea:

> It might be easier
> To fail—with Land in Sight—
> Than gain—My Blue Peninsula
> To perish—of Delight—[68]

The "Blue Peninsula" here refers to Italy, of interest both to Emily and to Kate, who eventually traveled there.

Rebecca Patterson argued that the "Blue Peninsula" also refers to Kate Scott herself.[69] Such an interpretation, with its erotic implications, either supersedes or subsumes the religious meaning of "The Sacrament—of Him" in the poem's second stanza. The paradox of the conclusion rides on the conflicting desires of consummation—gaining Kate Scott, her "Blue Peninsula" (and freedom from the solitary confines of the room)—and denial: here figured as drowning but also ambiguously a sexual awakening or renewal, "To perish—of Delight—."

Although these paradoxes reveal an ambivalent narrator, who is not entirely discomforted by her solitude, Cornell was struck by Dickinson's isolation. On August 28, 1953, his diary entry implicitly explained the emptiness of the box he had constructed. "Remembering preoccupations with E.D.," he wrote, "the void created by the constant deprivations of friend after cherished friend—the Wrenchings, the agony of 'not knowing where to land'

68. *The Poems of Emily Dickinson,* ed. Thomas H. Johnson (Cambridge: Harvard University Press, 1958), vol. 1, poem 405, p. 316.

69. Patterson, p. 149: "Kate Scott, or perhaps the love that she stood for, became the 'blue peninsula' of Emily's longing imagination." Although Starr (*Joseph Cornell: Art and Metaphysics,* pp. 79-83) acknowledges Patterson's interpretation and its significance for Cornell, she emphasizes the "Blue Peninsula" as a spiritual destination.

as explanatory (to a degree but not always) of the (intensity/increasing) of her awareness, perspicacity, etc." Here Cornell emphasized the poet's isolation and loss of friends (Kate Scott?), a "void" that he could readily visualize with an empty box. The triumph of Cornell's gift to the poet lies in its indeterminacy. The empty cage suggests escape and transcendence as well as desolation and despair. The sky is no less empty, even as Cornell has directed his heroine toward reconciliation with her lover.[70]

Another box that Cornell constructed, *An Image for 2 Emilies,* points to happier times, when the poet first met Kate Scott in 1859 (pl. 25). Deploying a grid format once again, Cornell placed in each cubicle a small chimney lamp containing a blue marble. The lamps allude to a moment of communication between Emily and Kate. Attending a party at her brother's next door, Emily stayed beyond the appointed hour and had to dash home as her father summoned. She lit an oil lamp in her bedroom window facing her brother's house, and story has it that Kate responded with her own.[71] The two Emilies, then, would be Emily and Kate, joined as lovers in the imaginative realm of Cornell's box, despite their separation across the lawn and later across

70. Diary entry, August 28, 1953, Cornell Papers, roll 1059, fr. 915. That Cornell was convinced by Patterson's interpretation is indicated by a comment in his diary: "Some of the Dickinson poems read, diminishing of biographies," he wrote, implying that biographies were inferior, ultimately, to the experience of reading her poetry. "But," he went on, "appreciation for Rebecca Patterson, one with its diagnosis, sense of values, discoveries, etc." (diary entry, October 6, 1952, Cornell Papers, roll 1059, fr. 593).

71. Patterson (p. 145) surmises that Kate Scott was the respondent from an anecdote related by Martha Dickinson Bianchi, Sue Dickinson's daughter, in *Emily Dickinson Face to Face: Unpublished Letters with Notes and Reminiscences* (Boston and New York: Houghton Mifflin, 1932). In describing a festive occasion, Bianchi states (p. 157), "the rest of that carefree crew only knew the coming of midnight by the warning rays of my grandfather's lantern advancing across the lawn on Emily's retreat. Then—a few minutes later, a light set in Emily's west window would flash a last good-night, and one answering from Sue's east window would shine back across the lawn a fond response."

Starr (*Box Constructions & Collages by Joseph Cornell,* p. 29 n) acknowledges this vignette as the basis of this box but also suggests that the two Emilies could refer to Dickinson's "light and dark" sides, as well as to Emily Brontë, whom Dickinson read and a reference Cornell also would have known.

25. Joseph Cornell, An Image for 2 Emilies, *c. 1954, mixed-media construction, 13-3/4 x 10-1/2 x 2-3/4 in. Collection Robert Lehrman, Washington, D.C.*

the sea. (The box when shaken sounds like sleigh bells, suggesting the sleighing parties that took place when Kate Scott visited the Dickinsons.)[72]

Cornell subsequently appropriated the grid structure of *An Image for 2 Emilies* for his series of mysterious "Dovecotes" which were inspired by his fascination with Dickinson (pl. 26). The connection first appears in a rather cryptic entry among his diary notes. On October 13, 1954 (once again Indian summer), Cornell "awoke with a kind of ineffable peace that imparted to some early work done in cellar (tiny colombiers) that enjoyment in work that is something connected with but over and above the work itself—anticipation this morning of finding at the Antique Fair something to 'supplement' the starkness of these 'white' pieces—thinking of E. Dickinson's 'Bonnie Alice' quote & its inspiration for the Dovecote series."[73]

What was the nature of the poet's contribution? The formal structure of the Dovecotes is similar to the compartmentalized boxes of the 1940s, which contain small bottles, packages, or toys. In 1949 an untitled box, informally known as *Forgotten Game* (pl. 27), which simulates the mechanical games found in penny arcades, joined its iconography with birds in their dovecotes. And, of course, the aviary motif had been implicit in *Toward the "Blue Peninsula."* Yet the empty Dovecotes had their most immediate origins in Dickinson's reference to "Bonnie Alice," a character in *Kavanaugh,* a novella by Henry Wadsworth Longfellow published in 1849. Emily's brother, Austin, had apparently "smuggled" the book into the house; it was avidly read by brother, sister, and his future wife, Sue Gilbert, as well.[74]

In a note to Sue, written around December 1850, Emily regretted not being able to pay a visit because of the weather. "Thank the wintry wind my

72. Robert Lehrman, the present owner of *An Image for 2 Emilies,* demonstrated this characteristic in an interview with the author, November 3, 1991.

73. Diary entry, October 13, 1954, Cornell Papers, roll 1059, fr. 1259.

74. Richard B. Sewall, *The Life of Emily Dickinson* (New York: Farrar, Straus, and Giroux, 1974), vol. 2, p. 683. Although Sewall, the definitive biographer of Dickinson, acknowledges Patterson's theory in speculating upon the poet's psychological difficulties (pp. 605-606 n), he gives little or no credence to her proposals in the body of his text.

26. *Joseph Cornell*, Untitled, *c. 1953, mixed-media construction, 10-1/2 x 7-1/2 x 4 in.*
Photograph courtesy The Pace Gallery, New York.

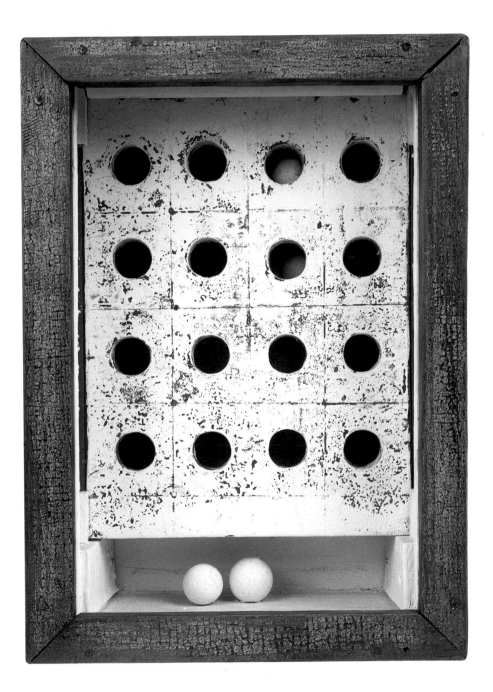

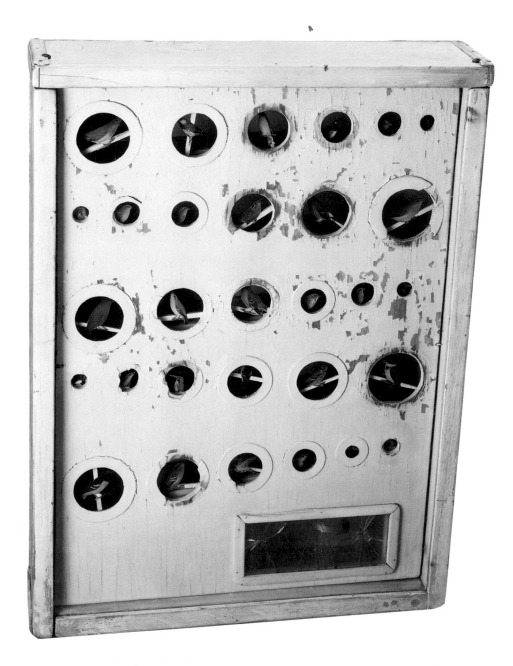

27. Joseph Cornell, Untitled (Forgotten Game), *c. 1949, mixed-media construction,
21-1/8 x 15-1/2 x 3-13/16 in. Lindy and Edwin Bergman Joseph Cornell Collection,
The Art Institute of Chicago. Photograph courtesy The Art Institute of Chicago.*

dear one," she demurred, "that spares such daring intrusion!" She continued with an extended allusion to *Kavanaugh:*

> You do not hear the wind blow on this inclement day, when the *world* is shrugging its shoulders; your little "Columbarium is lined with warmth and softness," there is no "silence" there—so you differ from bonnie "Alice." I *miss one* angel face in the little world of sisters—dear Mary—*sainted* Mary—Remember lonely one—tho, *she* comes not to us, *we* shall return to *her*! My love to *both* your sisters.[75]

In this complex passage Dickinson delineated two different absences. She herself was absent from her friend Sue, who had recently lost her sister Mary. At the same time, however, Sue had been reunited with another sister, who had returned to Amherst from Michigan—hence Dickinson's reference to "the little world of sisters." That the poet felt intrusive is indicated by her admonition: "Don't forget all the little friends who have tried so hard to *be* sisters, when indeed you *were* alone!" Her injunction "Remember lonly one" is ambiguously placed: is it the deceased Mary or Emily?[76]

Sustaining these nuances of desire, slight, and alienation is the allusion to "bonnie 'Alice.'" In Longfellow's story of a small New England town, Alice Archer is one of the protagonists, a meek, long-suffering young woman of very modest means and afflicted with a mysterious eye disease. She has fallen in love with Arthur Kavanaugh, a brilliant young minister, who in turn has fallen in love with the beautiful and wealthy Cecelia Vaughan, Alice's closest friend. When Arthur and Cecelia pledge their mutual love, Alice conveniently dies, thereby ending the love triangle, such as it was. In the context of Emily Dickinson's letter to Sue Gilbert, Sue was clearly Cecelia while Emily ambiguously associated herself with the rejected Alice.

75. *The Letters of Emily Dickinson,* ed. Thomas H. Johnson (Cambridge: The Belknap Press of Harvard University Press, 1958), vol. 1, p. 102. Cornell probably ran across Dickinson's allusion to *Kavanaugh* in Bianchi, pp. 186-87.
76. *The Letters of Emily Dickinson,* vol. 1, p. 102.

Longfellow referred to Alice's bedroom as a "columbarium," "a little sanctuary draped with white." Significantly, the room is empty when Cecelia enters, as Longfellow extended the metaphor: "the chair by the window, the open volume of poems on the table, the note to Cecelia by its side, and the ink not yet dry in the pen, were like the vibration of a bough, when the bird has just left it."[77] Dickinson noted by way of contrast that Sue Gilbert's nest was full. The conceit becomes even more explicit in the story because Cecelia purchased a homing pigeon that she trained to deliver messages between her and Alice. The pigeon is accidently intercepted by Kavanaugh, who sends Cecelia his declaration of love. The bird, however, flies to Alice, who in noble self-abnegation redirects the creature to Cecelia. The "columbarium," then, is both a dovecote *and* a sepulchre (holding funerary urns), just as the homing pigeon in the story communicates one love while it fatally disrupts another.

Dickinson's use of Longfellow's metaphor in her letter to Sue lent an edge to an essentially benign story. Her emotional needs had an urgency and intensity unmatched by "bonnie 'Alice'" or an idealized Cecelia. Cornell recast the economy of Dickinson's prose (and poetry) in his Dovecotes, with their austere geometry and vacant niches, some occasionally offering evidence of their inhabitants. The absent birds, however, are presumably delivering their messages, and will eventually return home. Connection was everything for Cornell, as with the poet's help, he found new meaning for a formal structure that had served him well for other visual motifs and themes.

With the emotional intensity compressed in the Dovecotes, Cornell keenly sensed that Dickinson was more than a mere "brown wren," a stereotype that a book reviewer in 1962 dismissed in *The Christian Science Monitor*. Cornell already knew of the risk faced by her admirers, who "lose much of their own identity and take on too much of Dickinson." But what sort of homage could he extend to the poet if he did not offer a binding gift of his own work? Cornell must have felt satisfied in looking back that his attachment to

77. Henry Wadsworth Longfellow, *Kavanaugh*, in *Longfellow's "Hyperion," "Kavanaugh," and "The Trouveres,"* intro. William Tirebuck (London: Walter Scott, 1887), p. 248.

Dickinson had been far from "wrong-headed and wrong-hearted," as the reviewer in *The Christian Science Monitor* characterized most of the poet's relationships with men.[78] Cornell had brought his sympathies to fruition over the distance of time.

In retrospect, Donald Windham's insight about Cornell's "Aviary" exhibition in 1950 was prophetic. "Birds are remarkable for the distances they travel, for their faculty, incomprehensible to man, of knowing the relations between remote places," he claimed. "The essence of Joseph Cornell's art is this same genius for sensing the connection between seemingly remote ideas, emotions and objects, and for presenting them in constructions with a subtlety which understands that the more remote, the more incomprehensible they are, the more vital and living they must be to have surmounted the barriers of time and space."[79]

78. John Holmes, "A Bomb, Not a Brown Wren," *The Christian Science Monitor* (Eastern Edition), March 8, 1962, p.6, a review of Theodora Ward, *The Capsule of the Mind: Chapters in the Life of Emily Dickinson* (Cambridge: The Belknap Press of Harvard University Press, 1961). Cornell had clipped out the review, which he saved in the front of Ward's volume (box c, Cornell Papers).
79. Donald Windham, *Aviary by Joseph Cornell* (New York: Egan Gallery, 1949-50), Cornell Papers, roll 1067, fr. 269.

Mad King Ludwig

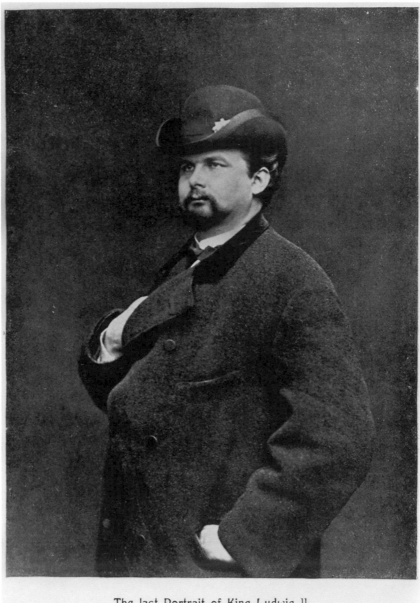

The last Portrait of King Ludwig II.

(United Art Est , Munich.)

28. *King Ludwig II of Bavaria in Hans Steinberger,* The Life of Ludwig II of Bavaria.

\mathcal{A}LTHOUGH A 1939 PERFORMANCE of *Bacchanale,* Salvador Dalí's new ballet about Ludwig II, the nineteenth-century king of Bavaria, may have piqued Cornell's interest, the eccentric king seems an unusual subject for an homage. For an artist whose attachments were intensely personal, Cornell would not appear to have had much in common with Ludwig, a monarch who reportedly committed suicide in 1886, after being declared insane during a coup of his court.[80] And yet Cornell began to compile a dossier on this "mad" king in 1941, a year or so after the performance by the Ballets Russes de Monte Carlo; he continued to amass material for more than a decade. The plain valise containing Cornell's research on Ludwig contrasts strikingly with the extravagant young king who idolized Richard Wagner and built several lavish castles for his own sybaritic pleasures. King Ludwig at Neuschwanstein seems far removed from Cornell in his modest house on Utopia Parkway.

Most of Cornell's homages were to women, and although he constructed tributes to men, they were relatively fewer in number. In contrast to the other dossiers that he assembled, Cornell's homage to King Ludwig (pl. 29) is remarkably reticent—perhaps wisely so, given the impossibility of ever matching the artistic and aesthetic excesses of the king. Then, too, the valise may simply contain material that Cornell, ever willing to defer projects and keep them open-ended, saved for future use. It is clear in any case that Cornell compiled the valise over a period of several years. Although this homage may seem more like an aggregate of elements than a sustained celebration of Ludwig, Cornell's elusiveness should not be mistaken for absence; his sensibilities and interests governed the subtleties of his gift to Ludwig—a resuscitation of the king as an extravagant patron of the arts, even, perhaps, as a conceptual artist, who commissioned others to carry out his ideas.

The interior cover of the valise reveals a sepia photograph of an outrageously

80. That Ludwig was eccentric and imperious, there is no doubt; that he was mentally unstable was also highly likely; the claim that he was clinically insane was a pretext for the palace coup, as discussed in Wilfrid Blunt, *The Dream King: Ludwig II of Bavaria* (London: Hamish Hamilton, 1970), pp. 203-16.

29. Joseph Cornell, Untitled (The Life of King Ludwig of Bavaria), *c. 1941-52, paperboard valise containing various paper materials and objects, 3-5/8 x 14-1/2 x 11 in. Photograph courtesy The Pace Gallery, New York.*

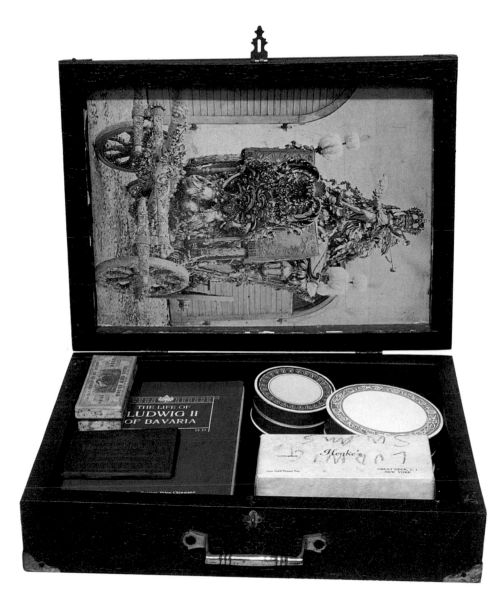

baroque carriage (pl. 30). Cornell left unadorned the rest of the interior, which compactly holds several small boxes of various shapes: a rectangular box advertising Henke's candy, a circular box for Royal Swan ribbons, and a blue packet containing photographs of the interiors of Herrenchiemsee Castle. Apart from their commercial labels, Cornell refrained from embellishing these boxes. The only exception is a small circular box within a box that has a marbled interior containing pieces of mica and a jeweled sash on marbled cardboard ("private garden fetes, etc. / for Richard Wagner").

Cornell also placed in the valise a handsome red copy of *The Life of Ludwig II of Bavaria* by Hans Steinberger, and a very deep blue folder at the bottom, containing miscellaneous photographs and clippings. More akin to a hagiography than a biography (translated from the German into English), Steinberger's book offers a portrait of Ludwig that idealized the king in ways that confirmed Cornell's values and interests.[81] Having found a spokesman to his liking, Cornell tipped in the text paper markers that silently provide clues to his attraction to Ludwig.

With the first marker, Ludwig is characterized as having had "a childlike innocent mind full of romantic ideas"—clearly a sensibility that Cornell would have appreciated. Steinberger continues with an androgynous portrait: "Pure and innocent as a child, sensitive as a woman, eager and ambitious as a boy to do great deeds, so was Ludwig II when he ascended the throne of the Wittelsbachers." Despite these inherent virtues, mixing "feminine" sensitivity with "masculine" assertiveness (providing for Cornell echoes of Mary Baker Eddy), Ludwig "died an unhappy, miserable man."[82] Could the king be saved? With his homage, Cornell would offer his gift of redemption.

Cornell subsequently placed markers at passages that suggest parallels between his life and Ludwig's. The young monarch's disastrous engagement to

81. In looking through Cornell's library, one realizes that Cornell often plundered books to corroborate his own ideas and attitudes.

82. Hans Steinberger, *The Life of Ludwig II of Bavaria*, trans. R. S. Goodridge (Prien, Germany: Franz Speiser, n.d.), p. 33.

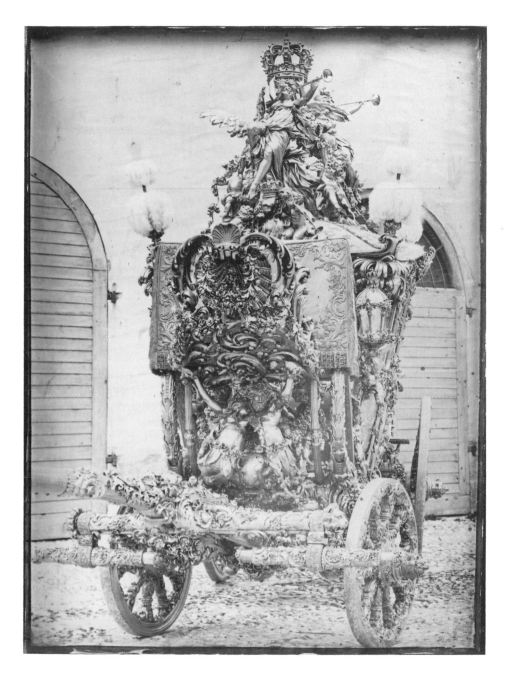

30. Joseph Cornell, Untitled (The Life of King Ludwig of Bavaria), *detail, the royal carriage, a sepia print lining the lid of the valise. Photograph courtesy The Pace Gallery, New York.*

his cousin, Archduchess Sofia of Bavaria, was terminated within six months. Without mentioning Ludwig's homosexuality, Steinberger suggests that the king "remained all his life the most chaste admirer of women." Cornell never married, and might fairly be said, like Ludwig, to have had an "exalted" idea of women.[83]

An equally important marker points to a melodramatic passage describing Ludwig riding to his brother, Otto:

> A heavy storm breaks over the lake—the giant trees in the Castle Park bend groaning beneath the wind as the royal carriage dashes past, and takes the forest road leading to Castle Fürstenried. It is to his brother Otto that the King is hastening. He alone can soothe and quieten the poor Prince, when visited by those terrible attacks [of insanity], in which, by Ludwig's strictest orders, the Doctors are to show him every possible consideration, and so it comes about that the brother's love succeeds, where Science fails.[84]

Cornell's brother, Robert, was an invalid from a young age throughout his adult life, requiring the artist's care and love.

Cornell found additional similarities: Ludwig's pacifism would have appealed to his inclinations during the Second World War; both were nocturnal creatures, Ludwig (elsewhere described as the "midnight king") carrying his nightlife to extremes; both were habitually restless, Ludwig changing castles on a whim. (Cornell's restlessness did not occur on such a grand scale, but he often felt a need to escape the confines of Utopia Parkway for the book stalls and thrift stores of Manhattan.) No wonder, then, that Cornell felt sympathetic toward Ludwig, perhaps, even, sensing that he was the king's double. When he started this *Life of King Ludwig of Bavaria,* Cornell was approaching forty: Ludwig was forty-two when he committed suicide, as Cornell noted on the back of a photograph of the king stored in the portfolio.

Although Cornell did not mark Steinberger's Epilogue, he would have

83. Steinberger, p. 59.
84. Ibid., p. 100.

agreed with the celebratory conclusion:

> We have shared the dream of a Royal Artist's life—have watched with wondering amazement the rising of this bright star, to see it suddenly cast down from spheres of light into the darkness of insanity. All that was mortal of this Prince has now returned to dust in the dark vault of his royal ancestors, but his genius shines forth immortally in his deeds.[85]

Cornell conveyed a sense of Ludwig as a tragic figure by filling a handsome circular box, somewhat larger than the rest, with marble fragments and shards, along with two swans, one glass and the other porcelain (pl. 31). Their discovery jars against the pleasure of opening other boxes in the valise and suggests the inexorable passage of time and the vanity of life. (Elsewhere, a small glass swan lies broken among a packet of swans.)

The king's tragedy came from his role as "Royal Artist," not from the "darkness of insanity," which, despite its plausibility, has the appearance of a charge trumped-up to depose him from the throne. In the grandest sense, Ludwig was a designer of environments. The sumptuous castles that he envisioned were architectural excesses, but their special indoor gardens and grottos were marvels of enchantment and illusion. Imagine ordering for Linderhof castle a replica of the Blue Grotto of Capri, a folly whose lights could be switched from blue to red to become the Grotto of Venus! Ludwig possessed, and was possessed by, *ideas* which he commissioned others to execute.

Cornell included in the blue folder a contemporary magazine account of Ludwig's rooftop garden (probably at Neuschwanstein). Described as a "fairy land," the garden offered a visitor "splendid palms," "rich, green foliage," and "a lake, on which float swans and various aquatic birds." Though this creation, complete with a boat, was not "mere illusion," the article gave credit for the garden to "the ingenuity of the machinist and the magic art of the painter."[86]

85. Steinberger, p. 154.
86. "Culture and Progress Abroad," *Scribner's Monthly* 3, 1 (1871), p. 121.

31. Joseph Cornell, Untitled (The Life of King Ludwig of Bavaria), *detail.*
Photograph courtesy The Pace Gallery, New York.

The swan, which had become a personal symbol for Ludwig (appearing on the royal crest of Bavaria), is predominant among the visual ephemera and memorabilia that Cornell collected for the blue folder in the valise. "Ludwig in Central Park," inscribed on a news photograph of a black swan snowbound in a pond suggests the extent to which Cornell had come to identify the swan with Ludwig. As the inscription further suggests, Cornell picked up this motif and sought its presence throughout contemporary culture, ranging from the swan logo for Macy's department store to snow swans for children, swans in zoos, and swan boats in the Boston Public Garden. Among these papers in the blue folder is a news clipping about swans as an endangered species: "Having no king to protect them, they got shot practically out of existence." Retrieving swans on matchbook covers, Royal Swan Ribbons, pencils with swan trademarks, and stamps bearing swans (from West Australia), Cornell symbolically began saving the swans in the absence of Ludwig.

The king's passion for swans may have extended back to childhood, when he was accustomed to their presence in the royal preserves. Swans entered the realm of opera, however, in Wagner's *Parsifal,* which premiered in Bayreuth in 1882, and earlier in *Lohengrin.* In the first, Parsifal shoots a swan; in the second a swan is revealed to be a young man under a spell. An analogous plot line exists in the ballet *Swan Lake,* where Odette, the enchanted heroine, is a swan by day and human only at night. She will be released from her spell only if a young man loves her truly and forever.

The swan motif mediated between Ludwig's love for the opera and Cornell's for the ballet. The king devoted his considerable energies and resources to supporting Wagner and mounting the Ring Cycles at Bayreuth. Ludwig's grand passion for Wagner was the sort of *amour fou* extolled by the Surrealists, who had taken refuge in New York at the time that Cornell began his homage to Ludwig. Cornell was unable to be a patron of the ballet as Ludwig was of the opera, yet his passion for the ballet was equally intense.

Never deterred by his infinitely more modest circumstances, Cornell understood the primacy of the imagination in constructing his own miniature environments in his boxes. With its recessive, mirrored interior and deep blue glass facade, *A Swan Lake for Tamara Toumanova* (pl. 32) captures the illusion of a blue grotto that Ludwig might have commissioned. The tableau commemorates the 1941 performance of Tamara Toumanova, who had become one of Cornell's favorite ballerinas, in *The Magic Swan,* adapted and enlarged from a scene in *Swan Lake,* staged by the Ballets Russes de Monte Carlo.[87] This gift in the guise of an homage to Toumanova was but one of many that Cornell made in carrying on the legacy of Ludwig's passion for the arts.

87. Sandra Leonard Starr, *Joseph Cornell and the Ballet* (New York: Castelli, Feigen, Corcoran, 1983), p. 64, convincingly claims that Cornell depicted a double image of Tamara Toumanova and Anna Pavlova in this construction.

32. Joseph Cornell, A Swan Lake for Tamara Toumanova (Homage to the Romantic Ballet), *1946, mixed-media construction, 9-1/2 x 13 x 4 in. Courtesy of The Menil Collection, Houston.*

Mad about the Ballet

33. Joseph Cornell, Untitled (Tamara Toumanova in "Moonlight Sonata"), *c. 1944, collage, 12 x 8-15/16 in. Photograph courtesy Richard L. Feigen & Co., New York.*

THE BALLET STARS whom Cornell visited backstage joined his favorite performers of the Romantic ballet in a timeless dance of his imagination. Yet he did not simply idealize his heroines but choreographed them in an ambiguous movement between past and present. Cornell's homages provided both a setting and a moment to capture the seductive presence of his ballerinas and respond to the subtle eroticism of the ballet.

In the late 1930s, Cornell met Tamara Toumanova through Pavel Tchelitchew, who designed ballet sets and therefore knew many of the performers. By all accounts, Cornell was star struck upon meeting the young Russian ballerina. Along with his letters, he was soon sending her small presents, which she graciously accepted. She sent him little gifts in return, including a small medallion of Saint Christopher, which was very suitable for an artist who voyaged constantly in his imagination. The gifts he treasured most, however, were bits and pieces from her costumes, some of which ended up in gifts that he made for her.[88] These included the fanciful *Boucle d'oreille pour Tamara Toumanova* (1940), "earrings" given a French touch, actually sequins and beads taken from one of her costumes and encased in a small circular box. By metaphorically translating these trinkets from costume bits to costume jewelry, Cornell transformed the balletomane's desire for souvenirs of his favorite ballerina into a modest gift of adornment.

Although Cornell expressed his adoration with these gifts, the ballerina sensed that he felt more comfortable admiring her from a distance. In one of his homages, a collaged figure of Toumanova, photographed in flight, reaches for a heart (pl. 33). The collage, based on Toumanova's performance in *Moonlight Sonata,* which coincided with her marriage in 1944, suggests that Cornell was offering her a farewell valentine.[89] He portrayed Toumanova as an

88. Toumanova to Cornell, undated, and May 16, 1942, Cornell Papers, roll 1055, frs. 337, 327-28.
89. Toumanova (Starr, *Joseph Cornell and the Ballet,* p. 68) claims that Cornell disapproved of her marriage: "He [Cornell] saw me not as a living creature but as a dream; a spiritual creature beyond flesh and blood" (p. 60). Starr notes that he distanced Toumanova by moving her into the past even as he brought Romantic ballerinas into the present (pp. 59-60). This movement, however, was sustained by an alternating current, not simple reversal, suggesting the ambivalence of his feelings.

etherealized ballerina, rendered even further out of reach by her move to California and subsequent marriage.

Such a portrait may indicate that Cornell simply bowed to circumstance rather than wanted to keep Toumanova at arm's length, as she contended. Another incident reveals an ambivalence that modulated his complex desires. In a letter to Parker Tyler on February 3, 1941, Cornell described a performance of *Aurora's Wedding* that he had attended. Irina Baronova had the title role. As Cornell's attention turned to Toumanova, his account shifts from the audience and ends backstage:

> Then all of a sudden I noticed (during Aurora's wedding) a person seated in street clothes in the wings. Bringing my opera glasses into play and moving over to the side I discovered none other than Toumanova sitting cheesecake fashion taking in the dancing of Baronova. Aurora watching Aurora! So for the rest of the show I watched her watching instead of seeing out the ballet. Went backstage afterwards and she gave me a royal welcome.[90]

Cornell began as a spectator and ended as a friend backstage in the intimacy of her dressing room. In the middle distance, Toumanova observed in the wings assumed a doubleness for Cornell, as he watched her observing a role (Aurora) that she would assume.

Cornell's use of the term "cheesecake fashion" suggests that he was hardly oblivious to her sexuality, though her erotic presence would remain understood rather than overtly stated. He was not loathe, however, for others to elicit her sexual powers as a dancer. A few months earlier he had thanked Tyler for his written "HOMAGE FOR TOUMANOVA," which unexpectedly arrived in the mail and made his day. Tyler claims the young ballerina, "the bride of her art," to be a "perfect" Aurora. The innocence of virginity, however, yields to an awareness of artistic perfection. Her smile of self-knowledge in the rehearsal mirror (another doubling) is an "innocent conceit" but "also the wanton look the bride dares to give her husband before the turning down

90. Cornell to Tyler, February 3, 1941, Ford Papers, HRC.

of the coverlet."[91]

By approving of Tyler's homage, which eroticizes the dance and the dancer, Cornell indirectly revealed the sexual charge of his own ballet imagery. A barely suppressed eroticism can be discerned, for example, in his 1942 *Homage to the Romantic Ballet* (pl. 34), which celebrates the great nineteenth-century ballerina Marie Taglioni, whom Cornell associated with Toumanova because they danced the same roles.[92]

The occasion for this hinged box that displays seven rough cubes of "ice" can be found inscribed on the interior of the lid:

On a moonlit night in the winter of 1835 the carriage of Marie Taglioni / was halted by a Russian highwayman, and that ethereal creature commanded / to dance for this audience of one upon a panther's skin spread over the / snow beneath the stars. From this actuality arose the legend that, to keep / alive the memory of this adventure so precious to her, Taglioni formed the / habit of placing a piece of ice in her jewel casket or dressing table draw / er, where melting among the sparkling stones, there was evoked a hint of / the starlit heavens over the ice-covered landscape.

The triumph of the dance over violence in this story heightens the erotic tension of the performance demanded of Taglioni by the bandit.

Though the incident occurred in the past, Cornell was surprised by its presence in his urban surroundings. This "modern aspect," he jotted among his notes, had the force of "revelation," when he saw "ice being loaded on to trains (seen through the grill gates of the Grand Central), spilling from supply trucks about the city." Such a flash inspired the "jewel-box with ice & snow"—all in turn evoking the "'feerie' of the ballet footlights."[93] Cornell's attempts to vivify the past seem somewhat strained in this instance. Despite a

91. Cornell to Tyler, January 10, 1941, Ford Papers, HRC; Tyler, "HOMAGE FOR TOUMANOVA," unpublished ms., Cornell Papers, roll 1055, frs. 302-303.
92. Starr, *Joseph Cornell and the Ballet,* p. 59.
93. "TAGLIONI-POE," Cornell Papers, roll 1066, fr. 1060.

fervid account, he felt constrained to clarify the connections of his urban metaphor rather than trust the viewer to experience a similar "revelation" that would join crystal jewels and blocks of ice.

Cornell's attempts to bring ballerinas of the past into the present were most successfully realized in an intense homage for the nineteenth-century Italian ballerina Fanny Cerrito, whose distractions he vividly entertained for more than a decade, continually summoning her into the present. (He may have felt challenged in part by a comment in *Dance Index* that she had never appeared in the United States).[94] By 1945 he had assembled another dossier, which he exhibited as *Portrait of Ondine* at The Museum of Modern Art. He associated Cerrito with her role as Ondine, the naiad who emerges from the sea to seduce a fisherman—a dangerous venture that risks mortality for sexual pleasures. Several boxes continue this homage to Cerrito. In an untitled construction of 1947, Cornell represented Cerrito as Ondine with a tiny ballerina figurine that appears Venus-like on a scallop shell behind a tulle veil (pl. 35).

An exhibition label for *Portrait of Ondine* at The Museum of Modern Art informed the viewer that "Mr. Cornell defines this show as an 'unauthorized biography' which recreates the atmosphere and climate in which the dancer lived and which may still be real and significant to us." Cornell claimed that he encountered Cerrito among the used book stalls of lower Manhattan, significant to him for their "anti-chronological" disorder. In this timeless zone, Cornell found a "rare and well preserved portrait . . . bringing the fair Italian disturbingly to life." He partially shed this metaphorical discourse, as "the figure of the young danseuse stepped forth as completely contemporaneous as the skyscrapers surrounding her." And so (with a return to the metaphor), "in the unfurling of an image was the danseuse set free."[95]

94. George Chaffee, "A Chart to the American Souvenir Lithographs of the Romantic Ballet, 1825-1870," *Dance Index* 1, 2 (February 1942), p. 28.

95. "PORTRAIT OF ONDINE," Cornell Papers, roll 1076, fr. 1303; diary entry, February 4, 1947, Cornell Papers, roll 1076, fr. 2; and notes, Cornell Papers, roll 1066, fr. 1266. Starr, *Joseph Cornell and the Ballet*, p. 19, notes that the nineteenth-century writer Gérard de Nerval also conflated dream and reality in bringing women alive.

34. Joseph Cornell, Homage to the Romantic Ballet, *1942, mixed-media construction,*
6-5/8 x 10 x 4 in. Lindy and Edwin Bergman Joseph Cornell Collection, The Art Institute of Chicago.
Photograph courtesy The Art Institute of Chicago.

35. Joseph Cornell, Untitled (Cerrito in "Ondine"), *c. 1947, mixed-media construction,
11-5/8 x 15-1/16 x 4 in. Photograph courtesy Richard L. Feigen & Co., New York.*

Furling and unfurling metaphors brought Fanny Cerrito to life.

In the freedom of Cornell's imagination, Cerrito occasionally made her appearance, as in a "mid-summer incident" toward sunset during a customary ride on the Long Island rail. "The twilight works its enchantment," he wrote, "and, dozing for a brief second the swirling and vivid form of Fanny (Cerrito?) executing a *pas* in masculine military costume has come and gone with (sword thrust) rapidity." Further transformations occur: "I am not surprised as the conductor now approaching for my fare turns out to be Fanny herself in theatrical military attire. With dignity she accepts my ticket, tempering the professional formality of her function with a direct and fleeting glance of adorable tenderness."[96]

In working over this material, Cornell cautioned himself in the margin that these accounts "should not be 'factual.'"[97] A casual reader, of course, falls prey to the discursive illusions of narration, illusions sustained by the intensity of Cornell's immersion in the experience at hand. Yet the conventions of twilight as a time of enchantment, coupled with the brief dozing, betray the dreamlike quality of Cornell's experience. As he did with Emily Dickinson and King Ludwig, Cornell offered his gift to Fanny Cerrito as alive in his imagination. The tension that he required in order to sustain his illusion took its charge from a nether-ground between an inert past and a banal present. To bring them to life, out of the past and into his art, was his goal and his gift.

96. "Fanny Cerrito Album; Mid-summer incident," with added location, "Long Island," Cornell Papers, roll 1058, fr. 897.
97. "Windows & Fanny Cerrito; Discovery-N.Y. 1940," with notation "retyped 7/8/44," Cornell Papers, roll 1058, fr. 896.

Penny Arcade Portrait of
Lauren Bacall

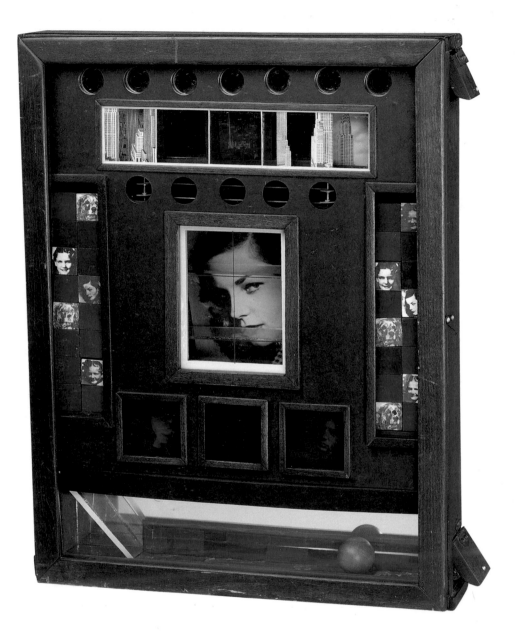

36. Joseph Cornell, Untitled (Penny Arcade Portrait of Lauren Bacall), *1945/46, mixed-media construction. 20-1/2 x 16 x 3-1/2 in. Lent to The Art Institute of Chicago by Lindy Bergman. Photograph courtesy The Art Institute of Chicago.*

\mathcal{O}N A RAINY MONDAY AFTERNOON on February 26, 1945, Cornell "decided to go to Keith's," a movie theater in Flushing, New York. He was of two minds about what he saw. Ernest Hemingway's *To Have and Have Not*, starring Humphrey Bogart and Lauren Bacall, seemed "pure Hollywood hokum," and the actress "disappointing" in her movie debut. Yet he crossed out this initial assessment in favor of a fascination with her close-ups. "Her profile in one shot [is an] absolute vertical," he noticed, as he had similarly focused on a close-up of Hedy Lamarr in *Come Live With Me* for his 1941 homage in the "Enchanted Wanderer." The purchase of an "icinged rum ring" left him with a "better than average feeling," offering the possibility that his "feeling of creation . . . invariably lost on returning [home]" might be retrieved.[98]

This unpromising rainy-day diversion gradually evolved into an homage for Lauren Bacall that transcended Cornell's customary adulation for movie stars. His homage to the young actress took the form of a box and a dossier (or portfolio). Though the box has remained untitled, the two are both known as *Penny Arcade Portrait of Lauren Bacall* (pls. 36, 37). This project is unique among Cornell's oeuvre as the most fully realized box and dossier combination. His homage to King Ludwig II of Bavaria remained a collection of material in a valise, with a hint of future projects, and his *Portrait of Ondine* in honor of Fanny Cerrito remained a portfolio of attempts to embody his elusive feelings for the ballerina. Other boxes, such as those with portraits of Renaissance children, took serial form but without the accompaniment of an extended portfolio.

By combining a box with a dossier, Cornell was able to complete one part even while leaving open the possibility of adding more material to the other. In tandem, *Penny Arcade Portrait of Lauren Bacall* offers complex permutations and combinations of themes, motifs, and forms with an elegant economy of means. Varying a format that had its origins in the early 1930s, this penny arcade plays upon the Medici Slot Machine motif that Cornell used

98. Diary entry, February 26, 1945, Cornell Papers, roll 1058, fr. 921.

37. Joseph Cornell, Untitled (Penny Arcade Portrait of Lauren Bacall), dossier, *1945/46 (added to after 1946), paperboard folder containing photographs and various paper materials. Folder: 11-15/16 x 8-11/16 x 3/4 in. Lent to The Art Institute of Chicago by Lindy Bergman.*

throughout the 1940s. Moreover, Cornell would eventually claim that with its deep blue glass facade and miniature photographs of Manhattan skyscrapers,"the 'penny arcade' symbolizes the whole of the city in its nocturnal illumination"—a "sense of awe & splendor . . . overriding [its] violence in darkness."[99] In the seductive figure of Bacall, Cornell invested his interest in movie stars and silent film, European and American culture, and in the process achieved a synthesis of high and low culture.

The moment was unique, for Cornell had come upon Bacall at the onset of her career. As a neophyte actress, still in her teens, Bacall had submitted herself to intensive training, especially in the cultivation of a husky voice, in order to develop her screen presence as a tough but sensuous young woman.

99. "'The Penny Arcade' (for Deidre*)," Cornell Papers, roll 1061, fr. 438.

In his "desire to write out Lauren Bacall box from [its] spiritual [point] of view," as he noted in his diary, Cornell recorded the progress of his own steps in constructing a cultural icon of the first order: the origins of *Penny Arcade Portrait of Lauren Bacall* were thus superimposed on the story of Bacall's cinematic birth, projected to a state of Edenic innocence before the Fall.[100]

In the dossier, Cornell gathered together photographs of Bacall, from her childhood to her adolescence and Hollywood stills; fashion photographs of her by Louise Dahl-Wolfe for *Harper's Bazaar* in February and May 1943; news clippings of movie advertisements for *To Have and Have Not;* clippings of Bogart and Bacall getting married on May 21, 1945 ("Bogey, a Bit Nervous, Sips Martini, Then Leads Lauren Bacall to Altar"); to feature articles in movie magazines, Bacall on the cover of *Silver Screen,* May 1945: "Suppressed Desires of the Stars."

The dossier also offers evidence of how Cornell designed the box itself. A mock-up of the facade (pl. 38) situates a Bacall photograph at the center of a sheet ruled off vertically to form rectangles. On the right column he glued exotic postage stamps (suggestive of Martinique, the film's setting) and on the left side, references to Taglioni, "[O]NDINE [P]ORTRAI[T]," "[Meta]physique d'Ephemer[a]," and "Souvenirs for Singleton."[101] These allusions and fragments indicate that Cornell thought of *Penny Arcade Portrait of Lauren Bacall* as part of a series of "Portraits of Women," which he would gather together for a "Romantic Museum" displayed at the Hugo Gallery in December 1946 (pl. 39). The elegantly printed fold-out for the "Romantic Museum" included a portrait in prose of Bacall, which Cornell had attached to the inside cover of the Bacall dossier. As a celebratory portrait of a young actress, then, the Bacall project echoed Cornell's paean to Hedy Lamarr as an "Enchanted Wanderer." At one point, he even entertained the possibility of titling the later work "A Penny Arcade Portrait of Lauren Bacall Becomes a Journey."[102]

100. Diary entry, August 2, 1945, Cornell Papers, roll 1058, fr. 929.
101. Bacall dossier, mock-up of the box facade.
102. Bacall dossier, "GENERAL WORKING NOTES."

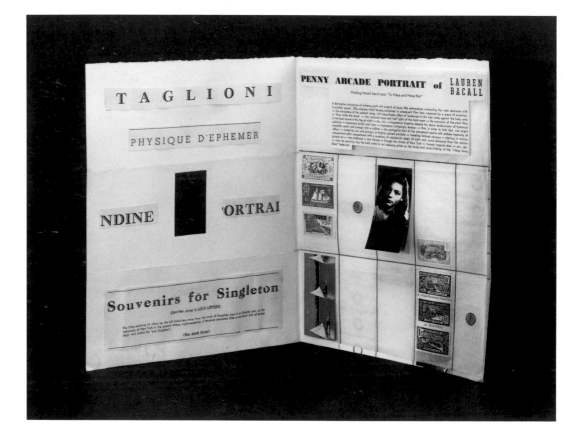

38. Joseph Cornell, Untitled (Penny Arcade Portrait of Lauren Bacall), dossier, *detail. Lent to The Art Institute of Chicago by Lindy Bergman. Photograph courtesy The Art Institute of Chicago.*

Within Cornell's own work, the format of the Bacall box extends back to an untitled assemblage of 1933, informally designated *Desmond,* which presents a *fin-de-siècle* female performer within a divided frame that contains shells and small balls along the upper horizontal (pl. 40). Such a format evoked the slot machines in penny arcades of Cornell's youth. He used this structural metaphor for his Medici boxes of the 1940s and early 1950s which combine portraits of Renaissance children with the mechanizations of slot machines (pls. 42-44). The flashy rectangular metal boxes of slot machines housed mechanical games and peep shows that could be set in motion for pennies. Cornell's *Forgotten Game* of 1949, a "slot machine," can actually be played by dropping a blue rubber ball into the box along a series of slides, hitting bells along the way until it emerges at the bottom (pl. 27). The Bacall arcade box has no bells, but can be played in the same fashion.

The silence of the Bacall box is consonant with Cornell's interest in silent film. In the dossier, he noted that "this can be an homage to the cinema as much as a personal portrait." As a consequence, he compared the "blue glass" facade of the box to the "night blue of early silent films." In a revision of his April 1945 notes, he amplified on this possibility as a "machine reminiscent of the early 'peep show' boxes (The first ones, Edison kinetoscopes, were installed in penny arcades) worked with a coin by plungers with an endless variety of 'contraptions.'"[103]

Cornell's association of a 1945 film with kinetoscopes and silent movies looked back to his celebration of Rose Hobart, the star of *East of Borneo,* a 1931 talkie, which Cornell radically transformed into a silent film in 1936, titled *Rose Hobart* (pl. 41). Seen through a deep blue filter and moving at a slightly languorous silent speed, *Rose Hobart* takes on a subtle

103. Bacall dossier, "This can be an homage," "GENERAL WORKING NOTES," and "Revised Notes of April 1945 / August 19, 1945—'PENNY ARCADE PORTRAIT OF LAUREN BACALL' (formerly, 'A Penny-Arcade Machine for L. B.')."

ROMANTIC MUSEUM

AT THE

Hugo Gallery

26 EAST 55th STREET, NEW YORK

D E C E M B E R

Unknown (The Crystal Cage)

Portraits of Women

Constructions and Arrangements

by

JOSEPH CORNELL

*39 a, b Joseph Cornell, announcement for the "Romantic Museum,"
Hugo Gallery, New York, December, 1946. Photograph courtesy Marianne Moore Archives,
The Rosenbach Museum and Library, Philadelphia.*

PENNY ARCADE PORTRAIT of LAUREN BACALL

Working Model based upon "To Have and Have Not"

A Botticellian slenderness of extreme youth with a touch of jeune fille awkwardness contrasting the rude assurance with irresistible appeal. (The sulleness which became uninspired in subsequent films here redeemed by a grace of sincerity). — the atmosphere of the cabaret songs, with indescribable effect of tenderness in the high notes against the husky ones in "How Little We Know" — the nocturnal mood and half lights of the hotel room — the evocation of the silent films in the boat scenes in the fog at night — etc., etc. — Impressions lingering despite the dense smoke-screen of hysterical publicity — impressions bright and clean — impressions intriguingly diverse — that, in order to hold fast, one might assemble, assort, and arrange into a cabinet — the contraption kind of the amusement resorts with endless ingenuity of effect — worked by coin and plunger, or brightly colored pin-balls — traveling inclined runways — starting in motion compartment after compartment with a symphony of mechanical magic of sight and sound borrowed from the motion picture art — into childhood — into fantasy — through the streets of New York — through tropical skies — etc., etc. — into the receiving tray the balls come to rest releasing prizes as the honky-tonk piano-tinkling of the "Hong Kong Blues" fades out.

Souvenirs for Singleton

(Jennifer Jones in LOVE LETTERS)

The little revolving tin clown on the old music-box strays from the trunk of forgotten toys in an English attic to the metropolis of New York in the present where, night-wandering, it becomes encrusted (like a merchant doll of former days) with tokens for "just Singleton".

(See Back Cover)

PORTRAIT of ONDINE

(Fanny Cerrito)

"Ecoute! — Ecoute! — C'est moi, c'est Ondine qui frôle de ces gouttes d'eau les losanges sonores de ta fenêtre illuminée par les mornes rayons de la lune; et voici, en robe de moire, la dâme châtelaine qui contemple à son balcon la belle nuit etoilée et le beau lac endormi".

"Gaspard de la Nuit" by Aloysius Bertrand

METAPHYSIQUE D'EPHEMERA

Unknown of Past and Present

Fugitive Impressions

Faces Seen But Once Faces Seen in Crowds

Tabloid Portraits

Pathos of the Commonplace

Girl in Pigtails — New York City

Summer 1946

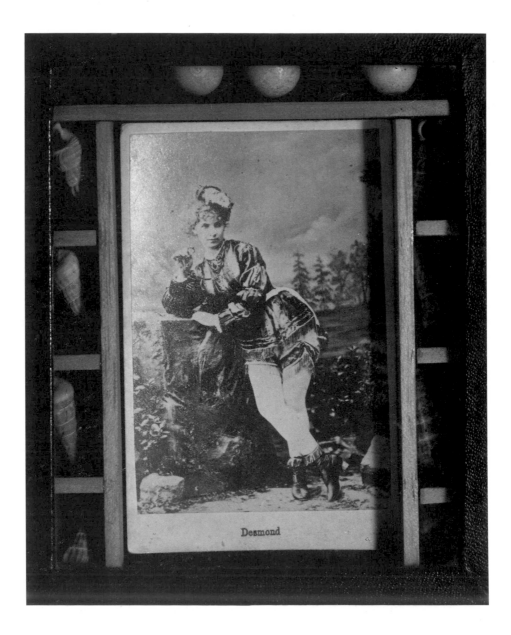

40. Joseph Cornell, Untitled (Desmond), 1933, mixed-media construction, 5-1/8 x 4-3/16 x 7/8 in. Private Collection.

erotic aura distilled from the sexy trash of the original.[104] Cornell also paid homage to Hobart by rescuing her from all the disasters and near-disasters that occur as her character in the Hollywood movie, Linda Randall, searches east of Borneo for her estranged husband. In the opening section of the original, for example, we watch a boa constrictor menacing Randall as she sleeps in a mosquito-netted enclosure on the barge bearing her to the interior kingdom of Prince Maradu. Cornell eliminated this snake from *Rose Hobart* so that we see only Rose, awakening in her safari garb.

A similar purification also takes place in *Penny Arcade Portrait of Lauren Bacall* with Cornell's inscription of a "spiritual point of view." The "purity of the original inspiration should be held to," he reminded himself, in following Mary Baker Eddy's emphasis on eternal spiritual principle as opposed to mere human personality, which was deemed mortal and corrupt. And so he wanted to cut through the "usual cheap Hollywood publicity" to distill a "portrait of a machine that belongs in a penny arcade—as genuinely as American as herself—but one with a shiny clean look, fumigated of Hollywood booze, cigarette smoke and slow-motion mugging."[105]

Cornell saw *To Have and Have Not* several times and came away admiring details of the film. He recalled Bacall "in black evening dress bare midriff singing / huge close-up of head turning as she takes in / audience with typical look . . . / . . . chiaroscuro lighting under lamp in Bogart's room / absolute vertical line of chin and brow"—the close-up that he would use as his central image for the box. As a result, he got beyond the fan's perception of "a new

104. Thomas Lawson ("Silently, by Means of a Flashing Light," *October* 15 [Winter 1980], p. 56) rightly notes, "Cornell takes this rather crude expression of sexuality [*East of Borneo*] and turns it into a refined erotic fantasy." Also see Annette Michelson, "Rose Hobart and Monsieur Phot: Early Films from Utopia Parkway," *Artforum* 11, 10 (June 1973), pp. 47-57, and P. Adams Sitney, "The Cinematic Gaze of Joseph Cornell," in *Joseph Cornell,* ed. McShine, pp. 69-89. *East of Borneo* (1931), directed by George Melford, starred Rose Hobart as Linda Randall, Charles Bickford as Dr. Randall, and Georges Renavent as the Prince of Maradu.
105. Bacall dossier, "personal notes for 'Penny Arcade Portrait of Lauren Bacall,'" October 1946, and "Revised Notes of April 1945."

41. *Film still from Joseph Cornell,* Rose Hobart, *c. 1936.*

slinky, sultry, sexy siren of the silver screen," beneath the "cheese-cake," to discover "a girl of Botticellian slenderness with a jeune fille awkwardness, . . . accentuating her 'hard boiled' and very honest and sincere qualities to a touching degree."[106]

Having come upon "some unexpectedly fresh (Kodak) pictures of her childhood," Cornell decided to portray Bacall "along the lines of A Medici Slot Machine."[107] This discovery added new meaning to the project. From the start of the 1940s, he had appropriated Renaissance portraits of children for the Medici series, which would extend over the decade to a Medici princess in 1948 and a Medici boy in 1953 (pls. 42, 43). Following the composition of the Medici boxes, he arranged Bacall's childhood snapshots (along with some snapshots of her cocker spaniel) in the columns flanking her portrait in the box. Thematically, the Medici boxes and *Penny Arcade Portrait of Lauren Bacall* focus on the purity of childhood, with a subtext of gender transformations.

Cornell moved through alternating portraits of boys and girls in his Medici boxes to an untitled work of 1948-54 that even allows the viewer to shuffle the gender of the central portrait of the box from boy to girl (pl. 44 a, b). In his Bacall notes (separate from the dossier), Cornell translated to the realm of film the sexual metamorphosis exemplified by this Medici box. On a page, titled "MEDICI PENNY ARCADE MACHINE," Cornell wrote a variation on a passage in "Enchanted Wanderer" in which he imagined that scenes in Lamarr's film *Come Live With Me* "were presided over by so many apprentices of Caravaggio and Georg[e]s de la Tour to create a benevolent chiaroscuro . . . the studio props dissolve . . . the girl in the golden shadows fades out into . . . a youth of the Quattrocento."[108] The androgynous portrait described in this passage which runs through a cinematic dissolve of a girl merging into a boy, is reinforced by

106. Bacall dossier, "'business' of 'TO HAVE & HAVE NOT,'" and "Revised Notes of April 1945."
107. Bacall dossier, "Revised Notes of April 1945." For an extended discussion of the Medici portraits, see Starr, *Joseph Cornell: Art and Metaphysics,* pp. 37-57.
108. "MEDICI PENNY ARCADE MACHINE," Cornell Papers, roll 1073, fr. 947.

Cornell's "Enchanted Wanderer" montage for *View* of Lamarr's face superimposed on a Giorgione reproduction of a Renaissance youth.

Cornell rendered these gender transformations with great subtlety by subordinating them to childhood innocence and purity. His strategy was set in *Rose Hobart,* whose lead character, her hair closely cut, is dressed at one point in jacket, jodhpurs, and boots. (For his film, Cornell eliminated from *East of Borneo* a cruel misogynous streak in Rose Hobart's husband, who refers to her scornfully as a "typical he-woman adventuress.") Androgyny, however, is but one of Rose Hobart's various guises in Cornell's film as her female identity remains evident throughout. By virtue of complex formal manipulations, the actress Rose Hobart becomes Cornell's creation, distilled from Linda Randall, her fictive counterpart in *East of Borneo.* This early effort at remaking a movie star anticipated Cornell's fabrication of Lauren Bacall in *Penny Arcade Portrait of Lauren Bacall.*

To Have and Have Not, the cinematic source for Cornell's tribute to Bacall, is full of sexual innuendo that plays with gender doubling and androgyny. Bacall's character, Marie, is a young woman at loose ends on the Caribbean island of Martinique, controlled by the French Vichy government. She meets Harry Morgan (Bogart), the American captain of a fishing vessel, who calls her Slim, a gender-neutral nickname. (When he is angry at her, he calls her "Junior.") She is, of course, svelte, though never to be mistaken for a boy. Morgan's male double is Eddie (Walter Brennan), an old alcoholic, who enjoys quizzing people, "Was you ever bit by a dead bee?" Marie responds with her own question: "Why don't you bite them back?" Eddie comes up with a beguiling double negative response: "But I ain't got no stinger!" Near the conclusion, *she* asks Eddie about the dead bee, gets to do the punch line with a simple negative ("I haven't got a stinger"), and so clarifies her gender.

As with the purifications of *East of Borneo* in *Rose Hobart,* Cornell repressed the androgynous elements of *To Have and Have Not* in the Bacall box. In the dossier, however, he noted that rumors of a male voice dubbed for Bacall's in her cabaret songs (Hoagy Carmichael at the piano) apparently

42. Joseph Cornell, Untitled, *c. 1948-54, mixed-media construction, 17 x 11-3/4 x 5 in.*
Photograph courtesy The Pace Gallery, New York.

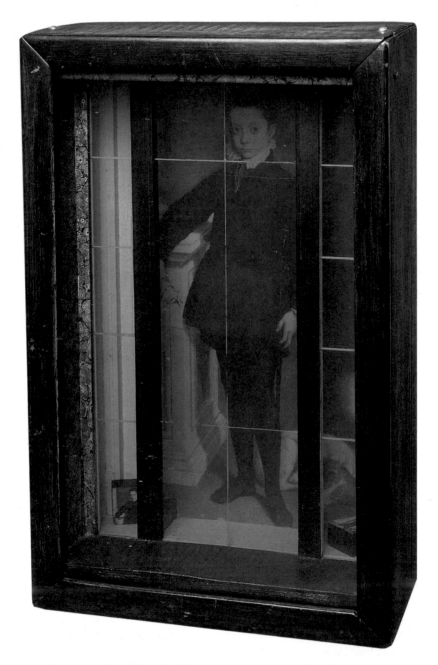

43. Joseph Cornell, Untitled (Medici Boy), *1953, mixed-media construction,*
18-1/4 x 11-1/2 x 5-1/2 in. Collection of the Modern Art Museum of Fort Worth,
Museum Purchase, The Benjamin J. Tillar Memorial Trust.

were "true." Even so, he still admired "her startling voice whose huskiness blends perfectly with her almost rude assurance but in the high notes of the song 'How Little We Know,' there is an indescribable effect of tenderness and extreme youth."[109]

In seeking to assemble a portrait of Bacall in her screen origins, Cornell was keenly aware of his competition with Hollywood decadence. He sought instead a "romantic 'afterglow'" in a penny arcade machine that would be metaphoric rather than literal. And so he finally felt the need to describe a box that could not exist except in his imagination:

> one might assemble, assort, and arrange into a cabinet—the contraption kind of the amusement resorts with endless ingenuity of effect—worked by coin and plunger, or brightly colored pinballs—traveling inclined runways—starting in motion compartment after compartment with a symphony of mechanical magic of sight and sound borrowed from the motion picture art—into childhood—into fantasy—through the streets of New York—through tropical skies—etc., etc.—into the receiving tray the balls come to rest releasing prizes as the honky-tonk piano-tinkling of the "Hong Kong Blues" fades out.[110]

In this wonderful passage, Cornell mixes the cabaret music of *To Have and Have Not* with the play of a slot machine, which dissolves through time and space in a blend of memory and desire. Past sexual difference, past childhood, Cornell wanted finally to give us "the dreams and inner visions of the poet-painters who portrayed a fresh and unspoiled world."[111]

109. Bacall dossier, "Revised Notes of April 1945." In her autobiography (*Lauren Bacall by Myself* [New York: Alfred A. Knopf, 1978], pp. 85-86), Bacall describes her efforts to lower her voice in developing her screen presence. While Bacall indicates that "one or two notes" were possibly dubbed in singing "How Little We Know" (ibid., p. 100), Lawrence J. Quirk (*Lauren Bacall: Her Films and Career* [Secaucus, New Jersey: The Citadel Press, 1986], p. 63) claims that Andy Williams' voice was dubbed. In any case, Cornell picked up the rumors of the dubbing and noted these in his dossier.
110. Bacall dossier, "Revised Notes of April 1945," and inside cover.
111. "MEDICI PENNY ARCADE MACHINE," Cornell Papers, roll 1073, fr. 947.

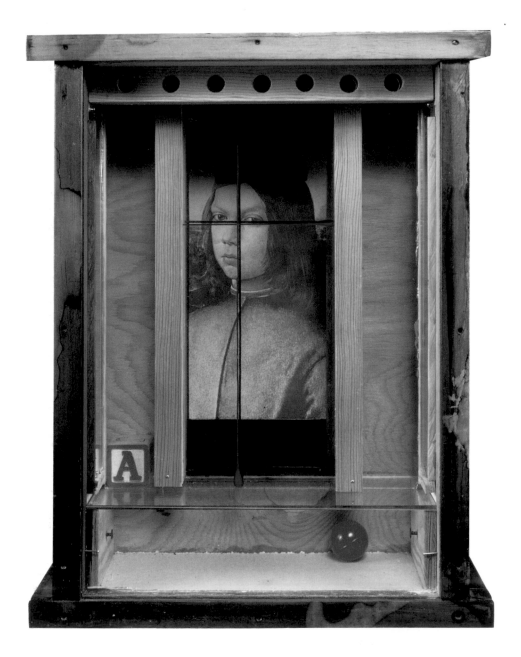

44 a, b. Joseph Cornell, Untitled, c. 1948-54, mixed-media construction 16-3/4 x 13 x 6-1/4 in. Two views. Photograph courtesy The Pace Gallery, New York.

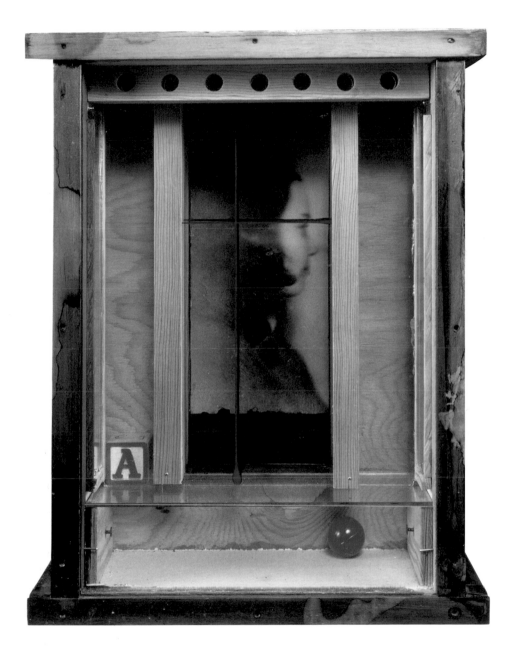

Conclusion

CORNELL'S INITIAL SKEPTICISM about *To Have and Have Not,* his distaste for the sleazy publicity surrounding Bacall, gave him a sufficient distance to work with the material at hand, to shape its meaning in *Penny Arcade Portrait of Lauren Bacall.* The coherence of his narratives about Bacall in the dossier contrasts vividly to the frenzied diary entries for his later collage *How to Make a Rainbow (for Jeanne Eagels).* As a consequence, *How to Make a Rainbow* remains intensely private, if not ineffable, despite its focus on a popular actress. The openness of *Penny Arcade Portrait of Lauren Bacall* is readily available in a dossier that reveals Cornell's meditations on a movie icon in the making. In his construction he sought to eliminate the dross and present the ingénue actress in a state of innocence.

Cornell's problems in translating an intense spiritual experience to his assemblage were perennial, not restricted to the assemblages he intended as gifts. He discovered, however, that he solved some crucial problems by giving gifts. The act allowed him to circumvent in part the need to enter his objects on the art market at a time when they did not meet demand. Gift exchange became a strategy that permitted Cornell to keep on making his objects. The pleasures of making were enhanced by the pleasures of giving. In the process, he was able to engage himself with others.

Because his objects were both art and gift, Cornell felt compelled to personalize them for others. First, his objects had to be directed to a specific recipient, as with his collage based on *The Young and Beautiful* for its star, Lois Smith. Then, by conceiving of his objects as homages to individuals whom he loved or admired, he gained a plenitude of themes and motifs for his work, as

with his work for the ballet and film actresses. At the same time his objects carried the personal touch of assemblage which by its very nature required Cornell's tactile manipulation.

The basic erotic nature of Cornell's work gained in subtle expression through sexual motifs of doubling and androgyny, finally to become openly erotic in his last years with his series of collaged images from "girlie" magazines. Though Cornell might have expressed such motifs in any case, they became coin of the realm in his gifts. Gift exchange requires human contact, real or imagined, a binding through mutual desire and pleasure (always imagined). Cornell self-consciously took up such themes in the work itself, as in *The Gift*. Ultimately, he used them as metaphors for his aesthetic and spiritual concerns, which went to the heart of his assemblage, in itself an art that joins disparate elements.

Cornell's generosity of spirit extended through the act of giving to the formal and thematic qualities of his objects, especially his homages, where he often rescued his heroes and heroines from the corruptions of human experience. He was content to invest his presence in the act of assemblage itself, in his choice of images and their deployment in box, collage, or dossier. At the same time, he minimized his presence by turning his work over to the object of his homage. The viewer explores the life of King Ludwig, participates in the making of a film star such as Lauren Bacall, admires the grace of Tamara Toumanova, the bravado of Léonor Fini. Cornell's subjects take center stage, redeemed through his invisible embrace, in his body of work.

Bibliography

ARCHIVAL SOURCES

Joseph Cornell Papers, Archives of American Art, Smithsonian Institution, Washington, D.C.

Charles Henri Ford Papers, Special Collections, The Getty Center for the History of Art and the Humanities, Santa Monica, California, and Harry Ransom Humanities Research Center, University of Texas, Austin.

Marianne Moore Archives, The Rosenbach Museum and Library, Philadelphia.

PRINTED SOURCES

Andreae, Christopher. "Cornell: boxes full of memories." *The Christian Science Monitor* (Eastern Edition), June 12, 1968, p. 14.

Ashton, Dore. *A Joseph Cornell Album.* New York: The Viking Press, 1974.

Bacall, Lauren. *Lauren Bacall by Myself.* New York: Alfred A. Knopf, 1978.

Benson, Sally. *The Young and Beautiful.* New York: Samuel French, 1956.

Bianchi, Martha Dickinson. *Emily Dickinson Face to Face: Unpublished Letters with Notes and Reminiscences.* Boston and New York: Houghton Mifflin, 1932.

Bingham, Millicent Todd. *Ancestors' Brocades: The Literary Debut of Emily Dickinson.* New York and London: Harper & Brothers Publishers, 1945.

Blunt, Wilfrid. *The Dream King: Ludwig II of Bavaria.* London: Hamish Hamilton, 1970.

Chadwick, Whitney. *Women Artists and the Surrealist Movement.* Boston: Little Brown and Company, 1985.

Copley, William. *CPLY: Reflection on a Past Life.* Houston: Institute for the Arts, Rice University, 1979.

Cornell, Joseph. "'Enchanted Wanderer': Excerpt from a Journey Album for Hedy Lamarr." *View* 1, 9-10 (December 1941-January 1942), p. 3.

Costello, Bonnie. *Marianne Moore: Imaginary Possessions.* Cambridge and London: Harvard University Press, 1981.

Dickinson, Emily. *The Letters of Emily Dickinson.* Ed. Thomas H. Johnson. 3 vols. Cambridge: The Belknap Press of Harvard University Press, 1958.

——. *The Poems of Emily Dickinson.* Ed. Thomas H. Johnson. 3 vols. Cambridge: Harvard University Press, 1958.

Eddy, Mary Baker. *Science and Health with Key to the Scriptures.* Boston: The First Church of Christ, Scientist, 1934.

Ernst, Max. *Dorothea Tanning* (New York: Julien Levy Gallery, 1944).

Fantastic Art, Dada, Surrealism. Ed. Alfred H. Barr, Jr. New York: The Museum of Modern Art, 1936.

Ford, Charles Henri. *Poems for painters.* New York: View Editions, 1945.

Hartley, Marsden. *Adventures in the Arts: Informal Chapters on Painters, Vaudeville, and Poets.* New York: Boni and Liveright, 1921.

Hölderlin, Friedrich. *Some Poems of Friedrich Hölderlin.* Trans. Frederic Prokosch. Norfolk, Connecticut: New Directions, 1943.

Hyde, Lewis. *The Gift: Imagination and the Erotic Life of Property.* New York: Vintage Books, 1983.

Joseph Cornell. Ed. Kynaston McShine. New York: The Museum of Modern Art, 1980.

Joseph Cornell Portfolio-Catalogue. Ed. Sandra Leonard Starr. New York: Castelli, Feigen, Corcoran, 1986.

Keller, Marjorie. *The Untutored Eye: Childhood in the Films of Cocteau, Cornell, and Brakhage.* Rutherford, Madison, and Teaneck, New Jersey: Fairleigh Dickinson University Press, 1986.

Kramer, Hilton. "Art: Joseph Cornell's Shadow-Box Creations." *The New York Times,* November 18, 1980, sec. C, p. 10.

Lawson, Thomas. "Silently, by Means of a Flashing Light." *October* 15 (Winter 1980), pp. 29-60.

Levy, Julien. *Memoir of an Art Gallery.* New York: G. P. Putnam's Sons, 1977.

Longfellow, Henry Wadsworth. *Kavanaugh.* In *Longfellow's "Hyperion," "Kavanaugh," and "The Trouveres."* Intro. William Tirebuck. London: Walter Scott, 1887.

Lynch, William F. *Christ and Apollo: The Dimensions of the Literary Imagination.* New York: Sheed and Ward, 1960.

Michelson, Annette. "Rose Hobart and Monsieur Phot: Early Films from Utopia Parkway." *Artforum* 11, 10 (June 1973), pp. 47-57.

Moore, Marianne. *The Complete Poems of Marianne Moore.* New York: The Macmillan Company and The Viking Press, 1972.

———. *The Complete Prose of Marianne Moore.* Ed. Patricia C. Willis. New York: The Viking Press, 1986.

———. "Notes on the Accompanying Pavlova Photographs." *Dance Index* 3, 3 (March 1944), p. 49.

Patterson, Rebecca. *The Riddle of Emily Dickinson.* Boston: Houghton Mifflin, 1951.

Quirk, Lawrence J. *Lauren Bacall: Her Films and Career.* Secaucus, New Jersey: The Citadel Press, 1986.

Sewall, Richard B. *The Life of Emily Dickinson.* 2 vols. New York: Farrar, Straus, and Giroux, 1974.

Starr, Sandra Leonard. *Box Constructions & Collages by Joseph Cornell.* Tokyo: Gatodo Gallery, 1987.

———. *Joseph Cornell: Art and Metaphysics.* New York: Castelli, Feigen, Corcoran, 1982.

———. *Joseph Cornell and the Ballet.* New York: Castelli, Feigen, Corcoran, 1983.

Steinberger, Hans. *The Life of Ludwig II of Bavaria.* Trans. R. S. Goodridge. Prien, Germany: Franz Speiser, n.d.

Taggard, Genevieve. *The Life and Mind of Emily Dickinson.* New York and London: Alfred A. Knopf, 1930.

Tanning, Dorothea. *Birthday.* Santa Monica and San Francisco: The Lapis Press, 1986.

Waldman, Diane. *Joseph Cornell.* New York: George Braziller, 1971.

Weld, Jacqueline Bograd. *Peggy The Wayward Guggenheim.* New York: E. P. Dutton, 1986.

Willis, Patricia C. *Marianne Moore: Vision into Verse.* Philadelphia: The Rosenbach Museum and Library, 1987.

Windham, Donald. "Joseph Cornell's Unique Statement." *The New York Times,* November 16, 1980, sec. D, pp. 27-28.

———. "Things That Cannot Be Said: A Reminiscence." In *Joseph Cornell: Collages, 1931-1972.* New York and Los Angeles: Castelli, Feigen, Corcoran, 1978, pp. 11-13.

———. *Aviary by Joseph Cornell.* New York: Egan Gallery, 1949-50.

Photography Credits

Thomas Cinoman, pl. 14

Edward deLong, pls. 3, 13, 24, 25

Hickey-Robertson, pl. 31

Bill Jacobson Studio, pl. 1

Joshua Nefsky, cover, pl. 7

Michael Tropea, pl. 37

David Wharton, pl. 42

© Ellen Page Wilson, 1992, pl. 30